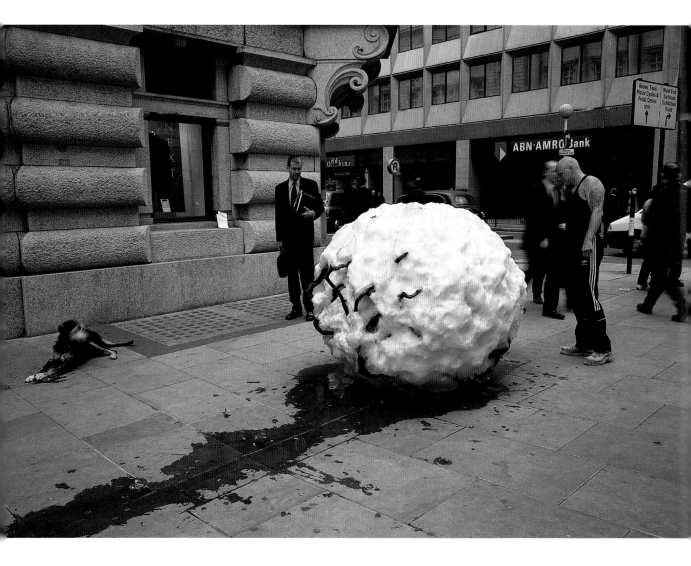

MIDSUMMER
SNOWBALLS

Andy Goldsworthy

Introduction by Judith Collins

 Thames & Hudson

First published in the United Kingdom in 2001 by Thames & Hudson Ltd,
181A High Holborn, London WC1V 7QX

British Cataloguing-in-Publication Data
A catalogue record for this book is available from the British Library

ISBN 0-500-51065-2
Printed and bound in Italy

Produced by Jill Hollis and Ian Cameron
Cameron Books, PO Box 1, Moffat, Dumfriesshire DG10 9SU, Scotland

Filmset in Stone Sans by Cameron Books, Moffat
Colour reproduction by Graphic Studio, Bussolengo
Printed in Italy by Artegrafica, Verona

CONTENTS

INTRODUCTION

Judith Collins

In August 358, a wealthy Roman citizen and his childless wife decided to leave their riches to the Virgin Mary and prayed for guidance as to how they should proceed. The Virgin Mary appeared to them in a dream and told them to build a church in her honour in a place that would be marked by a snowfall. On a very hot day in August they went to their land on the Esquiline Hill and there found a large patch of snow marking out the shape of a church. The couple paid for the church to be built on that very spot, and it was called Santa Maria Della Neve – Our Lady of the Snow.

A snowfall is often a joy and a surprise. It comes quietly and to its own timetable. It cannot be stage-managed or controlled. It often reveals things about the shape of the land onto which it falls. Goldsworthy is well known for working with what is to hand, and if he chooses to use snow, he has to wait until the conditions are right for its appearance. This book focuses on Goldsworthy's work with snowballs and snow drawings. Although he has made much work with ice, this medium is not included. Snow is malleable and soft; ice is flat, sharp and angular and makes very different shapes and marks. A large variety of shapes can be made with snow; if it is cut with a blade for making snow blocks for igloos, then it will have flat sides, but if it is moulded by the human hand, it will be roughly round in shape. When he was working at Grise Fjord, in the Canadian Arctic in March 1989, Goldsworthy had time to meditate on snow and ice and recorded these thoughts: 'Snow is stone – it is a white stone. Snow is like sand, ice is like slate . . . I have always considered snow and ice to be one of the most ephemeral of materials I have ever worked with, but here it has a feeling of permanence and it makes me realise how rhythms, cycles and seasons in nature are working at different speeds in different places.' When Goldsworthy placed thirteen snowballs in the City of London on Midsummer's Day 2000, their sudden appearance was as surprising as that of the snow on the Esquiline Hill in Rome in the summer of 358.

From 1975 to 1978 Goldsworthy was a fine art student at Preston Polytechnic, and in those years he experimented with ideas and actions, laying the foundations for the way he was to work as an artist. An influential book for art students in the 1970s was Lucy Lippard's *Six Years: The Dematerialization of the Art Object from 1966 to 1972*, which offered a detailed listing of art exhibitions, actions and events and texts from all over the world, chronicling 'minimal, anti-form, systems, earth or process art'. Goldsworthy

remembers being impressed by the work of two conceptual artists who were prominent at that time, Yves Klein and Joseph Beuys. He especially liked Yves Klein's photomontage 'Leap into Space' 1960, which showed Klein apparently throwing himself into space from the second-floor window of his dealer Colette Allendy's Paris apartment. Joseph Beuys was a charismatic teacher who showed his students new alternatives to the systems imposed by our socio-economic culture and tried to emphasise everyone's special creative faculties. He stated : 'the formation of a thought is already a sculpture' and 'even peeling a potato can be art'. One of his powerful performances – 'How to explain paintings to a dead hare' – took place in a gallery in Düsseldorf in 1965. Beuys had covered his shaved head with honey and goldleaf, transforming himself into a sculpture, and he cradled a dead hare in his arms. He showed the hare the pictures in the gallery: 'I explained to him everything that was to be seen. I let him touch the pictures with his paws . . . A hare comprehends more than many human beings with their stubborn rationalism.'

Several European and American artists took their work out of galleries and interior spaces and began to work with the land a decade before Goldsworthy. They were looking for new ways of dealing with nature, and Goldsworthy shares with them concerns with time and space, the ephemeral quality of natural materials, and the nature of their deterioration. Goldsworthy often works alone, using only natural materials found on site, making work that has only a minimal and temporary impact on its surroundings. This practice, which lies at the heart of his work, is similar to that of other land artists, including Richard Long. Goldsworthy's concerns in this regard echo the feelings expressed by Barry Flanagan who, in 1971, wrote: 'I prefer working with the essential stuff of sculpture rather than my own ambitions for it. This way I hope to find things . . .' Where necessary, however, Goldsworthy has always felt able to use tools, even motorised vehicles, to help him to achieve his aim. He counters any impression that he is 'a romantic working alone in the woods', and, indeed, many of his works have been executed in public rather than private places. The presence of the public is regarded by him as one of the elements that can influence a work, as much part of nature as the local weather conditions or the ephemeral state of his chosen materials. He equates the unexpected arrival of people when he is working with the unexpected arrival of rain or snow, events over which, he acknowledges, he has no control. Although Goldsworthy is not the first to work with snow, he has made the medium very much his own. The German artist Hans Haacke and the American Dennis Oppenheim worked with snow during 1968, while Joseph Beuys accepted full responsibility for any snow that fell in Düsseldorf between 15th and 20th February 1969.

Goldsworthy considers that his career began in 1976, while he was still technically a student. His first snow piece dates from January 1977, the first time in his career that snow fell and was available as a material for him to work with. That month, in woods near Leeds, he rolled snow into a large snowball just under a metre high and then pushed it around some trees, leaving a dark line on the ground where the snow had been gathered into the ball as it rolled along. This early work contains ideas that he has worked on and used many times since. Firstly there is the paradox of the spherical snowball making a flat line in the snow, resulting in the equation ball versus line. Then there is the white of the snowball leaving behind a dark trail of bare earth, making the

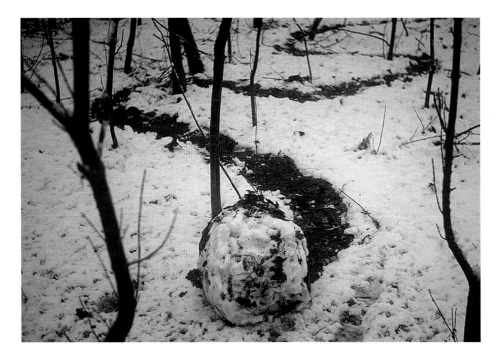

First snowball
Leeds, Yorkshire
January 1977

contrast of light versus dark, white versus black, negative and positive. The movement of the snowball around the trees draws attention to its construction, since this snowball was made by rolling and gathering. A snowball can also be made statically, its mass gradually built up with compacted handfuls of snow. But this January 1977 snowball was made by rolling a small sphere and increasing its size until it could be pushed no further. Goldsworthy gave the work some permanence by recording it photographically, as he has continued to do with all his ephemeral sculptures. 'Goldsworthy preserves these private oblations in exquisite photographs. He is one of the very few of the recent artists in the landscape to make a virtue of fine photography. While most others feel that photographic refinement obscures the true, non-photographic content of their work, Goldsworthy rightly finds it necessary for conveying the immaculacy of his efforts.' (John Beardsley, *Earthworks and Beyond*, Abbeville Press, 1998, p.50)

It is worthwhile pausing here in the chronology of Goldsworthy's career to give some attention to memory and transience. Most of Goldsworthy's work is made with natural materials such as leaves or sand or snow, and although he can appreciate the result of his labours when on site, for the enjoyment of others, he has to record the work mechanically. Many works have gone unrecorded and thus unappreciated, and these can be recalled only in his own mind and memory. This is not unprecedented in the history of sculpture. Many of the major sculptors of the Italian Renaissance, for example, made elaborate decorations for religious festivals, political parades and sporting events, intended to last only as long as the ceremony in which they appeared. 'They almost certainly played an important role in the formation and divulgation of style which we are no longer in a position to appreciate, for the majority were dismantled or abandoned as soon as they had fulfilled their function.' (Charles Avery, *Florentine Renaissance Sculpture*, 1970, p.9)

The next time it snowed in the part of Yorkshire where Goldsworthy was living was in February 1979, a few months after he had left college. There he made another

Opposite, above
Mud-covered snowball
below
Snowball made from last patch of snow on higher ground and brought to wood from which mud for snowball above was taken
Bentham, Yorkshire
1979

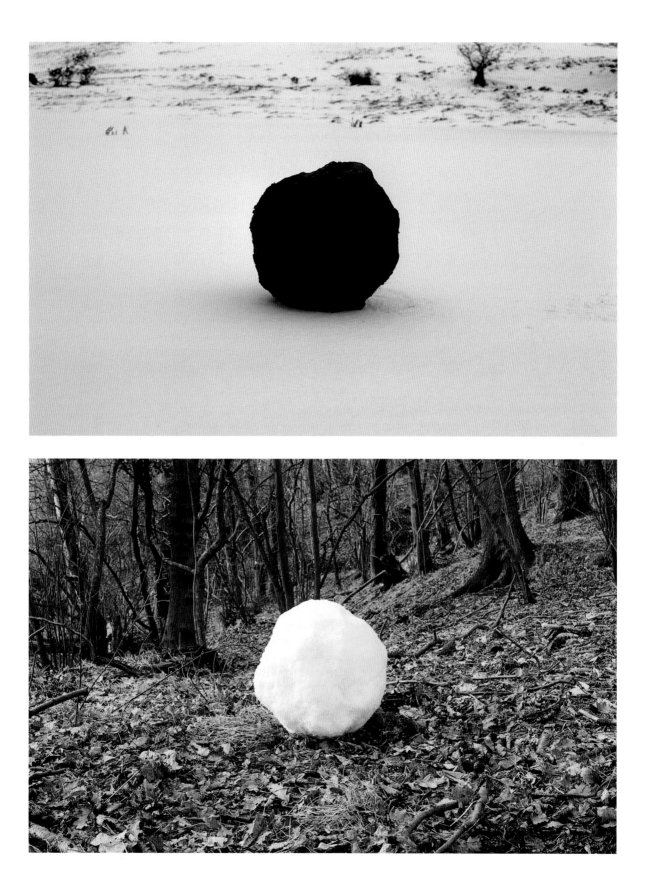

snowball about a metre high, but this time he covered it completely with black peaty soil collected from a nearby wood. He then placed this dense black sphere in the middle of a frozen pond, with the intention of creating the illusion of a black void floating in a white void. The heavily frozen and frosted surface of the pond pleased him greatly as it was a surface that he could walk on without leaving footprints. Thus, the work could appear as though there had been no human intervention in its making and placing, directly contradicting the supposition that it must somehow have been made by a person. This notion remains important to Goldsworthy for particular works and was crucial to the installation of 'Midsummer Snowballs'.

Goldsworthy remarks that one work often leads to another; the second may complement the first, or else contrast with it, pointing up particularities and differences. A short while after setting the black snowball on the frozen pond, Goldsworthy collected the last corner of snow hidden under a hedge, made it into a snowball and set it on the floor of the wood from which the black peaty soil had been taken: 'One of the first snowballs that I made as an artist was formed from the remains of a drift that had been protected from the sun by a tall and dense hedge. I carried the snowball into a nearby wood where it was the only snow around. Something that would have looked quite ordinary a few days before when snow lay thick on the ground now became extraordinary.' (Conversation with Conrad Bodman, early June 2000) Again, this work and the accompanying element of surprise adumbrate 'Midsummer Snowballs' in the City of London.

In March 1979 there was more snow in Yorkshire, and Goldsworthy, working at Clapham, introduced new ingredients into his snowball works. First he modelled a large snowball around the curved branches of a tree in such a way that the black branches appeared to grow out of the white sphere. Also in March and again in Bentham, Goldsworthy made a small snowball and coloured it green by rubbing the surface with crushed leaves. The following winter, in February 1980, once more at Bentham, he covered a large snowball with bracken, again making it into a dark sphere. He also placed an unadulterated white snowball onto an carpet of snow, so that, when recorded in a photograph, it complemented the earlier work. And at Robert Hall Wood in Lancashire in the same month, he placed a ball of snow high up on a slim vertical tree trunk, among a cluster of similar trunks, so that the snowball read as though it was floating in mid air; the photograph of this work, which denies the viewer a precise understanding of scale and position, can make it look like the moon in the sky. (*Andy Goldsworthy*, 1990, p.41)

In May 1981, in Ilkley, Yorkshire, after a late snowfall, Goldsworthy gathered the last of the snow found on high ground into a big ball, and with the help of his brother carried it to lower ground, to woods where the snow had already melted. He enjoys taking his work into a different environment, to see how it looks in a new place and to draw attention to the nature and quality of its material. A short while after placing the snowball in the woods and photographing it, Goldsworthy returned to look at it again and to take the first of a series of pictures of it melting. But as he approached it, a passing walker, who had spotted the snowball from a path close by, went over and quite deliberately kicked it into a nearby stream. Goldsworthy was taken aback by the man's reaction. Perhaps the fact that the snowball was out of place, that it should not have been there, which was one of the reasons for creating the work, was also the reason for its destruction.

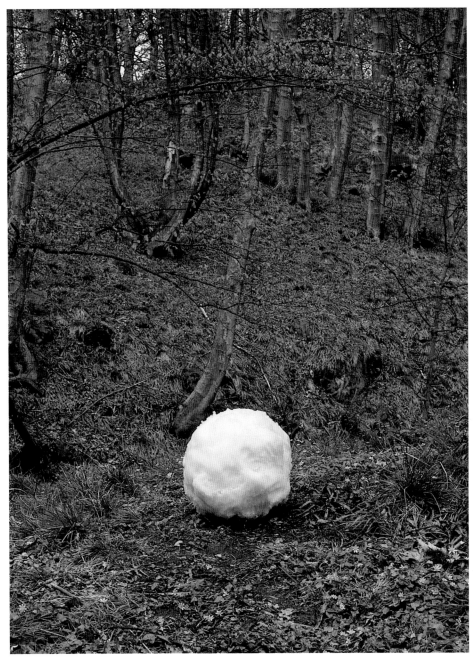

Snowball brought down
from high ground
Ilkley, Yorkshire
May 1981

In the winter of 1981-82, Goldsworthy changed his way of working with snow. Until that time he had accepted the ephemeral nature of the material, but now at Ilkley he made a medium-sized snowball and stored it in his mother's deep freeze. This was done with no future showing in mind, just the thought of delaying the transience, of being able to take the snow out of its seasonal context. The snowball came out of the deep freeze for a mixed exhibition in the summer of 1982 in the formal Italianate gardens at Tatton Park in Cheshire, called 'Sculpture for a Garden'. This was the first time that Goldsworthy had exhibited a deep-frozen snowball in the middle of summer, and

INTRODUCTION

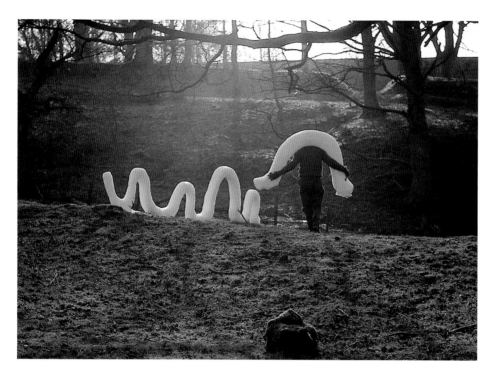

Carved snow
Helbeck, Cumbria
March 1984

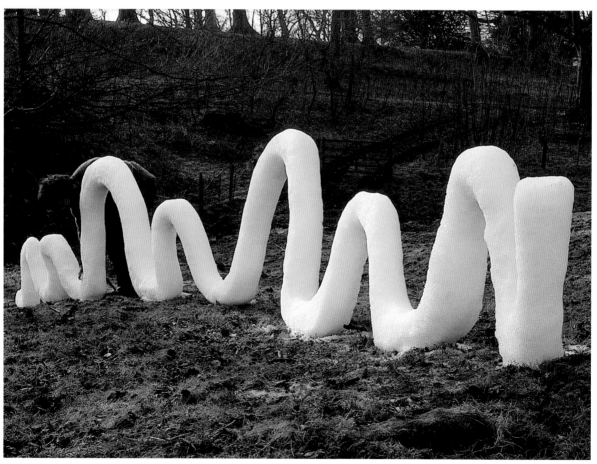

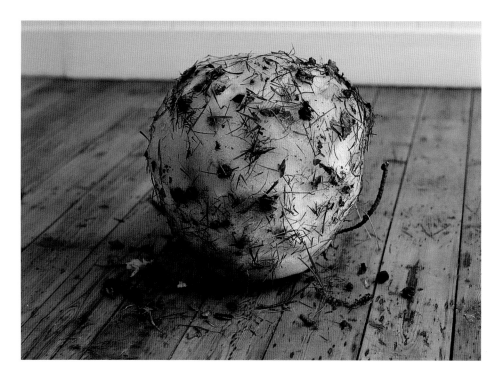

Snowball made in Ilkley, Yorkshire, April 1985 and allowed to melt at Coracle Press, Camberwell, London May 1985

allowed it to melt. He had previously tried to present this snowball as part of his solo summer show at the Serpentine Gallery in Kensington Gardens in July 1982, but his request had been refused.

In March 1984, by which time Goldsworthy was living and working at Helbeck in Cumbria, he had another chance to work with snow. On this occasion, instead of patting or rolling it into balls, he chose to carve frozen lumps of it with a stick into undulating curves, rather like the contours of a meandering stream, or the winding track created by rolling a large snowball around between trees. He carried these curved snow forms about 150 paces away to where there was no snow and set them up afresh in a grassy meadow.

The idea of exhibiting deep-frozen snowballs had by now taken hold in Goldsworthy's mind, but it was not until Simon Cutts offered the artist a show at his marvellous small gallery, the Coracle Press at 233 Camberwell New Road, London, in May 1985, that an opportunity presented itself again. In April 1985, after a late snowfall, Goldsworthy had made a ball from this wet snow and frozen it. Rolled into the snowball was whatever was lying on the ground at the time, including some daffodils. On 3rd May the frozen snowball was set directly on the wooden floor of the Coracle Press gallery, where it lasted for three days. As it melted, the contents of the snowball deposited a circle of debris around the place where it had stood. This fall was neither contrived nor ordered in any way: 'During the making, it had picked up debris – sticks, seeds, flowers – and these came out in the melt. Daffodils appeared as yellow lights as they came to the surface. I realised there was great potential in incorporating materials during the snow-balls' construction which would emerge in the melt'. (Goldsworthy/Bodman, 2000) Thus, a serendipitous happening had caused Goldsworthy to think of deliberately filling the next deep-frozen snowball, so that this natural fall of material could happen again, but in a more controlled manner. The show at Coracle Press was called 'Evidence'

and the flower debris left on the gallery's wooden floor after the snowball had melted seemed a poetic illustration of the idea.

The lessons learnt from the rejection of the snowball at the Serpentine Gallery and the melting of the debris-filled snowball at the Coracle Press Gallery needed to be implemented, and Goldsworthy looked around to try and find a context for new work of this kind. He made few snow works between the summer of 1985 and the end of 1988, simply because there was not much snow. The Tramway gallery in Glasgow (then the Museum of Transport) offered Goldsworthy an exhibition for July 1989, and he decided that this was the moment to present several deep-frozen and specially filled snowballs in an urban context in high summer.

With help, during January 1989, he made eighteen large snowballs at Blairgowrie, Glen Shee, in Perthshire. He had expected an abundance of snow at that time, but was confounded by three weeks of unseasonally mild weather. He remembers the tension he felt in waiting for the snow, wondering when it could come and how much would fall: 'The wait was as important as the making. Sometimes I felt I was coaxing snow out of the sky. When it did snow it released an urgency that gave the snowballs energy.' The number of eighteen snowballs was decided upon after the gallery space at the Tramway had been measured up. 'Once the process had begun the snowballs exerted their own demands, becoming an independent force that had to be won from the mountains in a way that reminded me of how a quarryman talks of winning a rock. This effort and tension has given the snowballs qualities I never thought of.'

The snowballs were stored in the Christian Salvesen refrigeration depot at Blairgowrie, not far from where they were made. Then on 28th July, they were driven to Glasgow in articulated lorries and released from their temperature-controlled chambers into the Tramway gallery, a space which originally housed trams. The snowballs were set in three rows of six, placed between the metal tramlines. The eighteen fillings had been decided upon and collected well before the snowballs were made, mainly within a small radius of Goldsworthy's home and studio in Dumfriesshire, where he was, by then, based. They were: fallen pine needles, dogwood, reeds, oak sticks, pebbles, horse chestnut stalks, fresh pine needles, slate, chestnut leaves, soil, chalk (collected for him in Dorset), ash keys, willowherb stalks, daffodils (harking back to the chance gathering in 1985), birch twigs, stone and pine cones – all well loved and well known materials, utilised many times in previous sculptures; one snowball contained purely snow. The snowballs took about five days to melt. 'When snow melts', writes Goldsworthy, 'things hidden slowly emerge – evidence of time laid on the ground. Rocks carried in avalanches, soil crumbling from an eroded bank, bird droppings, feathers, the remains of the kill, fruit, windblown twigs, leaves . . . caught up in the fall and the movement of snow. Removed from place and season – suspended in snow and time . . . Each snowball will have a different theme and pattern as it melts. Materials will emerge and concentrate on the surface, then fall. Different snows melt at different rates. I will not fully understand each snowball until it has melted. I am, however, deeply aware of their potential. The elements of the melt will be best understood in the quiet stillness of an indoor space. The snowballs will speak louder having been made in the mountains yet melting in the city.' (*Hand to Earth*, Leeds City Art Gallery, 1990) When the eighteen snowballs melted in the Tramway, Goldsworthy was most captivated by the debris and

Opposite,
and following four
pages:
'Snowballs in Summer'
Tramway, Glasgow
July 1989

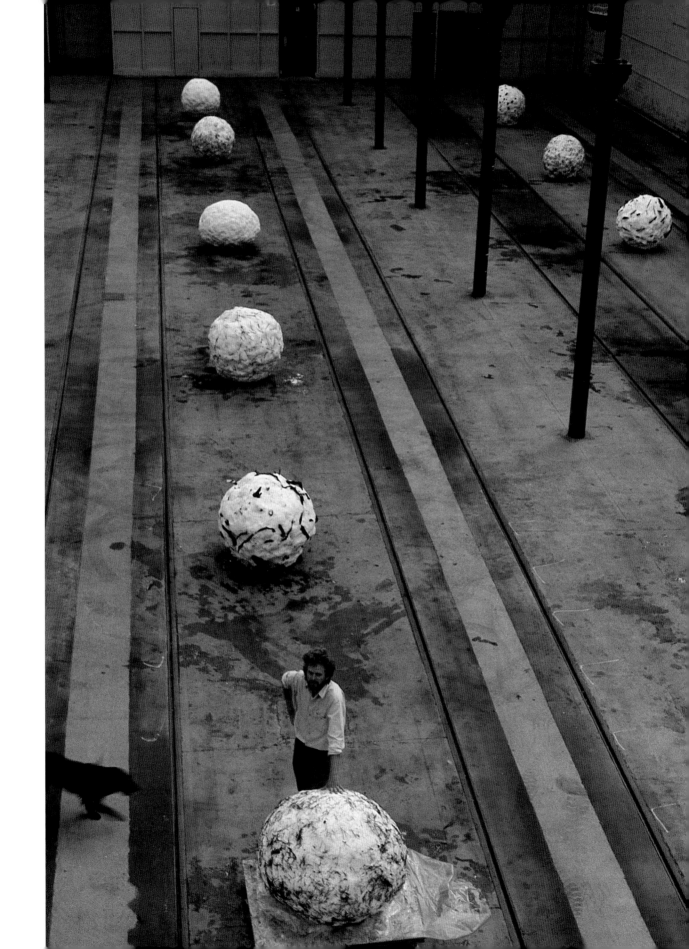

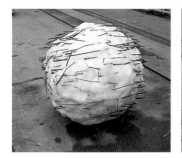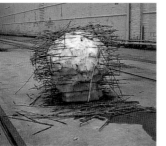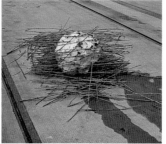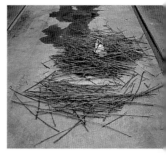

WILLOWHERB STALKS

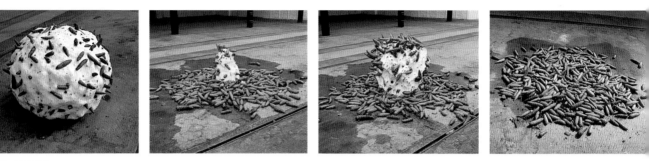

PINE CONES

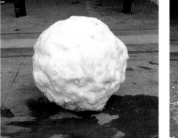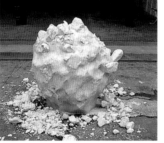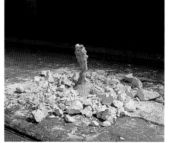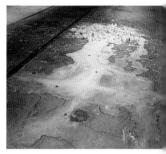

CHALK

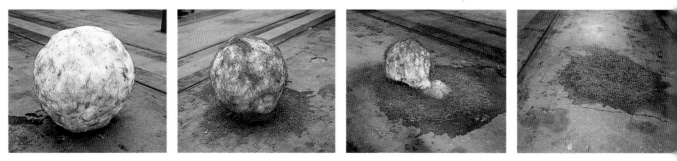

OLD PINE NEEDLES

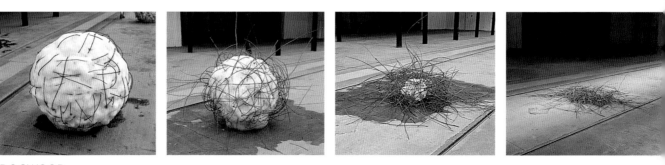

DOGWOOD

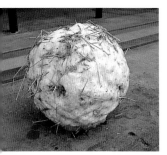 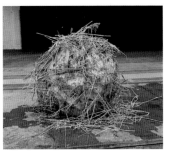 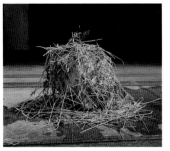 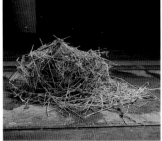

REEDS

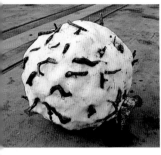 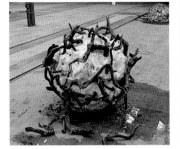 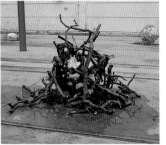 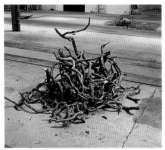

OAK STICKS

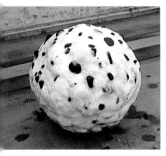 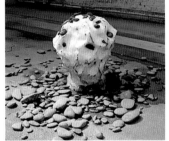 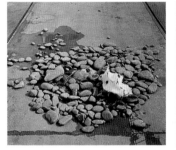 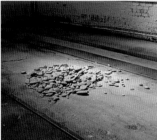

PEBBLES

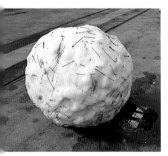 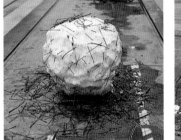 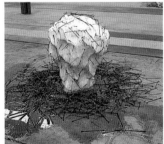 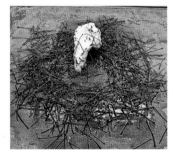

HORSE CHESTNUT STALKS

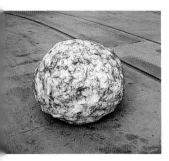 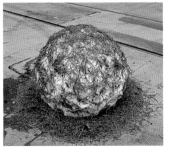 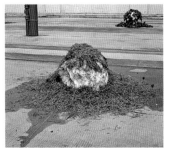 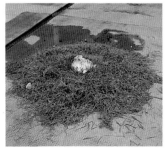

FRESH PINE NEEDLES

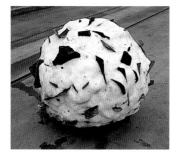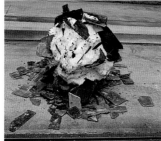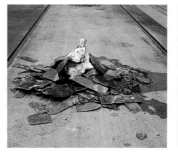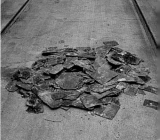

SLATE

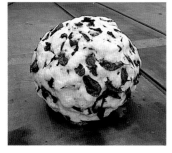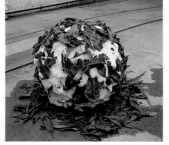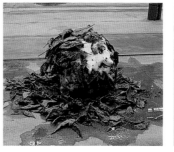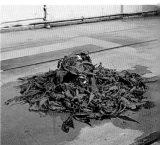

HORSE CHESTNUT LEAVES

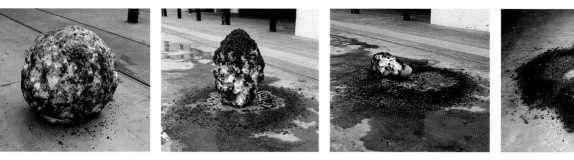

SOIL

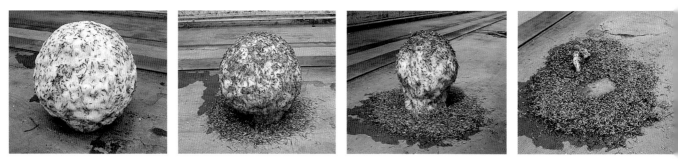

ASH KEYS

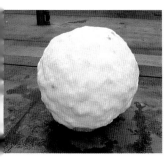 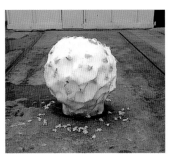 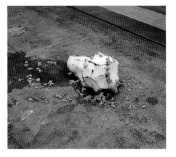 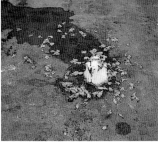

DAFFODILS

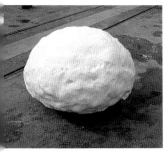 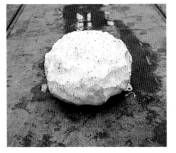 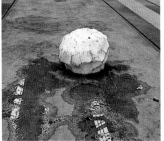 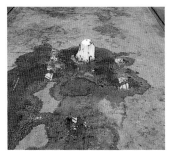

SNOW

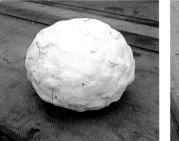 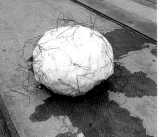 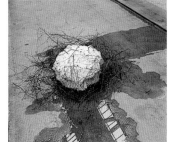 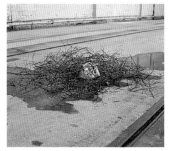

BIRCH TWIGS

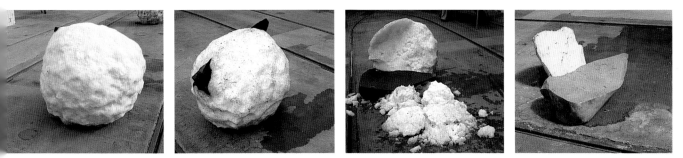

STONE

INTRODUCTION

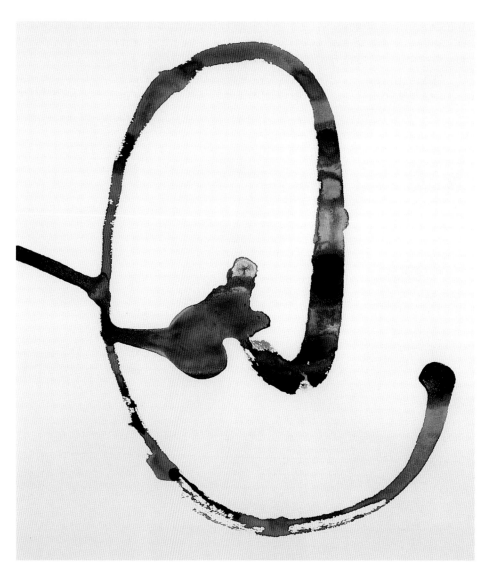

Seal blood
snowball drawing
Ellesmere Island
Canadian Arctic
March 1989

stain left by the chalk-filled one. He remembers realising then that he could draw with the contents on the gallery floor, in an aleatory way.

He had been helped to this conclusion after making a snowball drawing a few months previously, while he was involved in a residency in the Canadian Arctic at Grise Fjord, Ellesmere Island, from 22nd March to 20th April 1989. When Goldsworthy spent time at Grise Fjord, a 'place where snow never melts', he was in the land of the Inuits, and he had an Inuit guide, Looty Pijamini, as his helper. The Inuits have survived for more than four thousand years in the elemental world of the Arctic, where temperatures fluctuate between extremes of minus 60 and 30 degrees Celsius. Their continued survival in such an unforgiving yet beguiling environment has given the Inuits a deep and total attachment to their surroundings and a respect for what it offers, primarily blocks of snow for shelter, and stone, bone and skin for the utensils of daily life. Goldsworthy learned much about snow at Grise Fjord : 'I used 4 different types of snow today and Looty had words for all of them and there was a point when I wanted to stick snow – to hold the

snow together and he said we put this powdery snow on – not this type of powder but that type of powder. One was a very icy powder and the other wasn't . . . We stopped at some well wind-packed snow which Looty said was good for what I wanted but isn't what they would use for snow houses because this snow has too much air in it and he described it as "cold snow". Whereas they would be looking for something else, what they would call "warm snow" . . . I found this snow is very strong and good to work with but it doesn't have a lot of tolerance. I am used to a snow that is frozen – this isn't frozen, it has been packed by the wind . . . it is not wet snow frozen. And it will suddenly just break if you handle it too roughly. The cold has given the snow here a particular quality and energy, and wet is not a part of its nature.' (Andy Goldsworthy, *Touching North*, Fabian Carlsson and Graeme Murray, 1989) For the Inuits, for Looty the guide, snow is a basic utility, not primarily a material for making art, although Goldsworthy is aware that they do make small snow sculptures for their own pleasure, of which no evidence remains.

Along with snow sculptures, Goldsworthy made his first snowball drawing there, which had its origin in a hunting incident. 'One day on Ellesmere Island, Looty, my guide and assistant, went hunting with his son. I accompanied him, intending to make work nearby. We came across a seal hole in a crack in the ice which a seal had used to breathe.' Goldsworthy watched and waited while the guide shot the seal through the hole and harpooned it out onto the snow, placing it on a sled to take it home. 'A thick, deep-red blood dripped from the seal's mouth onto the ice. There was something potent about that warm dark blood in a frozen white landscape . . . I felt I should mark these moments. It is difficult to make a work about seals . . . and hunting without it becoming too loaded and emotive in a way that misrepresents what happened. I gathered snow and seal blood into red snowballs, letting one melt through my fingers leaving a trail of drips on paper which appeared as bloody tracks. I placed another snowball on a sheet of paper. After it had melted a little, I moved it in a gesture that might have been that of a surfacing seal as it swam towards its breathing hole.'

The killing of the seal on Ellesmere Island was a powerful experience for Goldsworthy, while it was a daily occurrence for Looty and his son – for them, the seal represented food and clothing. Goldsworthy, being a witness to this event but an outsider, felt that he had to find a way of working with the killing of this animal, and gethering its dark blood into a small snowball was a cathartic act. When he saw the results of its melting, a whole new body of work was released – snowball drawings. With most of them, Goldsworthy does not move the snowball once he has placed it on the paper to melt. But with this first seal blood drawing, he felt moved to make a spiral shape, a flourish, with the snow and the blood, so that the resulting ovoid stroke echoes the shape the seal would have made as it swam up to the breathing hole.

The Ellesmere Island snowball drawing experience in March 1989, followed by the filled snowball melts in Glasgow four months later, gave new impetus and purpose to Goldsworthy's snow drawings: 'In the following winter I collected snowballs mixed with earth and berries, which I left to melt on paper. Most were unsuccessful. They were not strong enough. By the time I had reached the studio most of the colour had drained away and the resulting stains were too weak. With subsequent snowballs I collected earth and snow separately – joining the two just before their being given to the paper.'

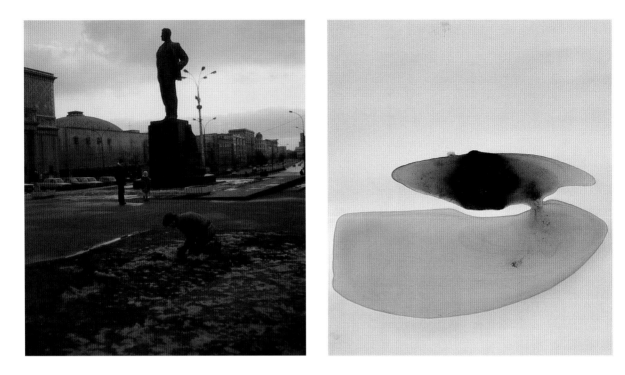

In the winter of 1990, he used seeds mixed with snow at Drumlanrig in Scotland to make further drawings. Goldsworthy calls his snowball drawings 'landscape paintings', alluding to the way in which the paper reacts to the water as though it was itself a landscape in the making. The sheet of paper, chosen for the support for the filled snowball, acts like a geological layer of the earth. Landscape is shaped and eroded by water, by the effects of snow, ice and running water flowing over and through its layers. The snowball melt echoes this, with the paper becoming an active part of the drawings, as the water released from the melting snowball makes it bend and buckle. 'When the snowball has dried I shake the paper and brush off the loose earth with a feather. This is for practical reasons, but I also like the feeling of erosion that this gives the work. The initial flows and layers are revealed – a landscape beneath a landscape – as the land itself.' Goldsworthy finds that different humidities in the paper and in his studio have a powerful effect on the 'landscape paintings'. If he changes the temperature in the room, the paper reacts in different ways. Snowball drawings take about two or three days to form, and he has to control the flow of air around the paper to prevent it growing mould, although he feels sure that he will eventually allow some to become mouldy to learn more about this effect. He is always delighted by the beginning of the melt, which appears 'as a little trail just like a growing seed'.

Snowball drawings with a variety of contents have continued at regular intervals since their dramatic beginning at Ellesmere Island. In March 1991 when Goldsworthy was working in Russia, he made a series of snowball drawings with city-stained snow gathered from public squares in Moscow, showing that his work can respond equally well to urban environments.

In August 1992, Goldsworthy was given the first exhibition of his ice and snow drawings at the Fruitmarket Gallery, Edinburgh, during the Edinburgh Festival. Although

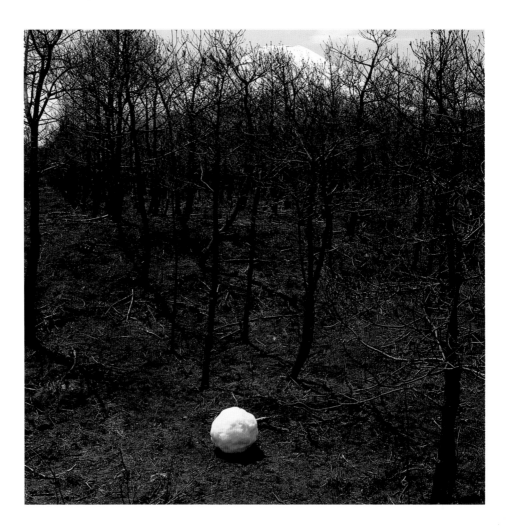

Mount Fuji snowball
placed in a burnt black
wood
Nashigahara, Japan
11 May 1993

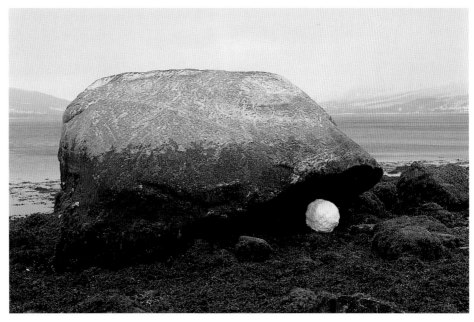

Snowball
below Ben Nevis
Scottish Highlands
12 January 1993

INTRODUCTION

the drawings were made horizontally, they were hung on the walls of the gallery rather than being laid on the floor. Goldsworthy explained: 'this group of works is hung vertically, usually with the snowball occupying the upper portion. I do not feel inclined to show the drawings as the snowballs melted – laid flat. If I were to do that they would become less visual. They are responses to nature as seen from a distance where the underlying river and rock structures are apparent – they are landscapes. If made to be seen lying flat then I would (and probably will) make snowballs with the intention of staining the floor itself.' This eventually happened, as Goldsworthy assumed it would in time, with the snowball filled with ground-up red stone which was allowed to melt and stain the floor of the Curve gallery at the Barbican Centre in August 2000. In May 1993, while working at Nashigara in Japan, Goldsworthy made his largest snowball drawing to date, conceived to link two continents. 'A Meeting of Mountains' consists of a snowball with earth from Mount Fuji left to melt at one end of a four-and-a-half-metre length of paper, while at the other end of the paper is an existing drawing made by a snowball laden with earth from Ben Nevis in Scotland. Goldsworthy has learnt through working with snow in Japan and in the Arctic, as well as at home in Britian, that 'each type of snow that I use is a concentration of the weather that has formed it'. (*Touching North*, 1989). He happened to be working at the Setagaya Art Museum in Tokyo during February and March 1994 when Japan experienced its heaviest snowfall in twenty-five years, and the unlooked-for but bounteous amount encouraged Goldsworthy to make a huge snowball which he set outside the museum, at first surrounded by snow, but soon the only surviving snow itself.

The experience of taking the eighteen snowballs to the Tramway, Glasgow, in summer 1989 and letting them melt inside the gallery, threw up in Goldsworthy's mind the possibility of repeating the exercise, but next time outside, in a fiercely urban setting. And this nearly came to pass in Chicago. Goldsworthy was there in February

Drawings for three of many possible locations selected for the Midsummer Snowballs project in the City of London
Tippex on photographic prints
1998

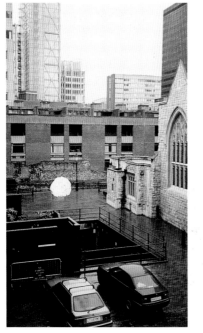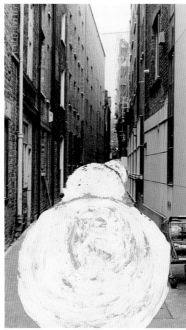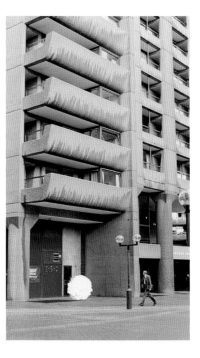

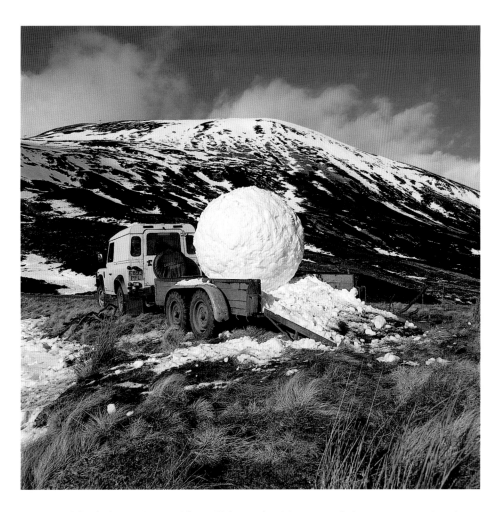

Snowball ready to be
transported to the
cold store
Glen Shee, Perthshire,
early 1999

1998 and had discussions with staff from the Museum of Contemporary Art there
about a project to make American snowballs in winter, filled with seeds and other
organic matter, deep-freeze them and then release them in summer at various points
on the streets of Chicago. He studied the city, took snapshots and drew white snow-
ball shapes onto his photographs with Tippex, working out how they would look and
where they could be placed. He wanted to make snowballs at the end of the 20th
century, deep-freeze them and then release them and their contents in the 21st century.
The American project foundered, and the idea had to wait until it found a sympathetic
venue, which proved to be the Barbican Centre in London.

The snowballs set inside the tram sheds in Glasgow, followed by the discussions in
Chicago, prompted the idea of placing snowballs outside in an urban environment –
not in an exhibition venue, but actually on the streets. Goldsworthy was interested in
the way the snowballs would be observed. He rightly surmised that very few people
return to an art gallery over a period of a few days, but that if snowballs were set in a
busy London street, people would see them on their way to work in the morning, and then
revisit them on their way home. The following morning, they might well approach
them with a sense of anticipation, to discover what had happened to them. Placing snow-
balls in central London venues would, he felt, encourage a dialogue with passers-by;

he would, however, have to place his trust in Londoners not to deliberately destroy them. He had, after all, watched a snowball in Leeds being kicked to pieces. The vulnerability of the snowballs would be part of the work. 'Confrontation is something that I accept as part of the project though it is not its purpose.'

Having decided to fill the snowballs for London, he reviewed the contents of the eighteen Glasgow ones to consider which would be appropriate for London. He kept chalk, pebbles and ash keys from the Glasgow fillings, and introduced beech branches, sheep's wool, crow feathers, horse chestnuts, Scots pine cones, elderberries, barley, barbed wire, Highland cow hair, and fragments of agricultural machinery found rusting in fields. The new materials contained references to animals as well as plants, not least in order to remind Londoners that the food they eat derives ultimately from the countryside, that the population is sustained by what lies beyond the city.

He was pleased with the Barbican area as a venue for his snowballs because he wanted to place them in as uncompromisingly urban a setting as possible, the very opposite of the landscapes in which they were made. Also interesting to him was the fact that the Barbican is both one of the oldest and one of the newest parts of London, holding within itself a tremendous sense of change. Roman remains and remnants of the old city wall still survive; the meat market at nearby Smithfield has been held there since the 12th century. Heavy bombing during the Second World War, which laid waste much of this area, revealed the earlier layers. For two decades the forty acres of the Barbican area lay undeveloped. The current Barbican Centre, with its high-rise flats, offices and cultural centre, was completed in 1982.

The first seven of the fourteen snowballs destined for the Barbican were made in Scotland in Dumfriesshire and near Blairgowrie, Perthshire, in January and February 1999. They were constructed, not rolled, filled with their contents and then driven on a trailer to a cold store in Dumfries. The other seven were made in the same way in Perthshire in December 2000. All were around two metres in diameter, and each weighed between one and two tons. The number of fourteen was chosen simply because that was how many could be fitted into two articulated lorries for the eventual journey south.

Goldsworthy was well aware of the meticulous organisation that would be needed to install such large yet vulnerable objects over a square mile of city streets between midnight and six on Midsummer morning, 21st June 2000. A snowball would have to be placed in its chosen location every twenty to thirty minutes if the element of surprise was to be maintained. Everyone would be working against time. All teams, lorries and fork-life trucks had to be absent as dawn broke. No evidence of the effort involved in the installation should be visible so as to allow the snowballs to speak for themselves: a silent, yet subversive, presence.

When dawn broke on 21st June, the morning was cool and cloudy and remained so – a typical English summer's day. Goldsworthy had been anxious about temperatures and rates of melting. A relatively cool temperature meant that, if physically unattacked, the snowballs would last longer than if the weather became hot. Their real enemy, however, would be mild temperatures and rain. In the event, the weather remained overcast, but mainly dry.

Thirteen snowballs were placed in a variety of city locations, most of them directly onto streets and pavements, with a few protected in courtyards and behind fences or

gates. The contents of some of the snowballs made reference to their locations, in particular the Highland cow hair, which was placed near to Smithfield meat market. Three filled with ash keys, horse chestnuts and Scots pine cones were set on the pavements in Silk Street, at the entrance to the Barbican Centre; two at Moorgate were filled with elderberries and beech branches; a snowball containing chalk was placed in the graveyard at Bunhill Fields; a pair filled with sheep's wool and crows' feathers was set in Charterhouse Square; a barbed wire snowball was placed behind a locked gate in St John Street, and another containing discarded and rusted bits of tools and agricultural machinery was set in the yard of an old shop in Lindsey Street. The barley-filled snowball was placed on the corner of Long Lane and Lindsey Street, while further along Long Lane, adjacent to Smithfield Market, sat the one filled with red Highland cow hair, clipped from animals in fields near to Goldsworthy's home in Dumfriesshire. Pebbles from the River Scaur in Scotland filled the snowball set in a bastion on London Wall.

The fourteenth snowball was kept back, in order to be placed directly on the floor of the Curve gallery in the Barbican Centre for Goldsworthy's exhibition 'Time' which was to open on 31st August 2000. This was filled with red stone ground into a powder, the stone being taken from a river close to Goldsworthy's home: 'I have worked with this red all over the world – in Japan, California, France, Britain, Australia – a vein running around the earth. It has taught me about the flow, energy and life that connects one place with another. The reason why the stone is red is its iron content, which is also why our blood is red.' (Goldsworthy/Bodman 2000) The red stain that would be made by this snowball would resonate with the many uses Goldsworthy has made of red since his first snowball drawing with seal blood at Grise Fjord. Health and safety regulations

Snow and earth drawings
Runnymede Sculpture
Farm, California
June 1994

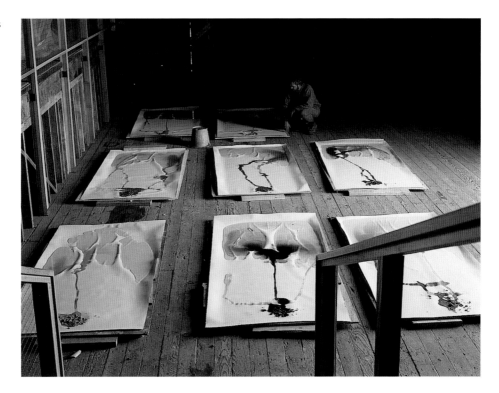

INTRODUCTION

prevented Goldsworthy from letting this last snowball melt at the opening of his exhibition, so he had to install it a few days earlier and stay alone with it as it melted, monitoring the flow of water and the growth of the red stain on the gallery floor. In a way its absence made it more impressive – visitors were left with its memory and its 'shadow' as evidence that it had been there and had been transformed by its surroundings.

The Curve gallery exhibition 'Time' also contained a specially made video and photographs of the Midsummer Snowballs, so that those visitors who had not experienced them first-hand could become acquainted with them through other media. Goldsworthy himself acknowledged that he had much to learn from the exhibition and the memory of 21st June 2000: 'With a project as complex as Midsummer Snowballs it may be some time before I fully understand its results. Photography, film, installation and the exhibition will articulate some of these results and at the same time will, I hope, push the ideas contained within the project in new directions.' (Goldsworthy/Bodman 2000)

Asked recently if he ever had thoughts of making a snowball last indefinitely, Goldsworthy pondered on the interesting parallels he might find between a ball of snow melting when it is exposed to summer temperatures and a ball of molten metal hardening as it cools to a similar temperature. So perhaps a Goldsworthy snowball cast in bronze is not beyond the bounds of possibility.

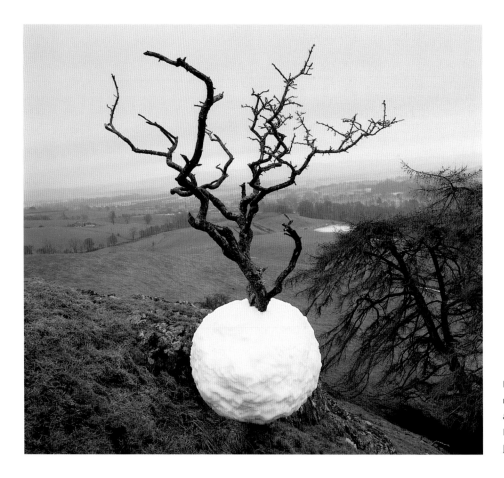

Hawthorn tree snowball made from the remains of a drift sheltered by a wall Penpont, Dumfriesshire January 2001

MIDSUMMER SNOWBALLS

This text is based on a conversation between Andy Goldsworthy and Conrad Bodman, Curator at the Barbican Art Centre, early in June 2000.

Snow provokes responses that reach right back to childhood. A snowball is simple, direct and familiar to most of us. I use this simplicity as a container for feelings and ideas that function on many levels.

Even in winter each snowfall is a shock, unpredictable and unexpected. Occasionally I have come across a last patch of snow on top of a mountain in late May or June. There's something very powerful about finding snow in summer. It's as if the whole of winter has drained through that white hole – a concentration of winter.

The snow used in the snowballs made for the Barbican was collected in the winters of 1999 and 2000 at Glen Shee, in Perthshire, where I made the snowballs for the Glasgow show in 1989, and in the Lowther Hills close to where I live in Dumfriesshire. It ranged from a very wet, thawing snow to dry, powdery snow, both of which are difficult to work. A snow that is somewhere between thawing and freezing is good. Freshly fallen snow is best.

It takes between three and six hours to make each snowball, depending on snow quality. Wet snow is quick to work with but also quick to thaw, which can lead to a tense journey to the cold store. The other extreme is powdery snow that is too cold to compact, and that means waiting for the temperature to rise before starting work. Towards the end I discovered that sprinkling water onto the snow made it workable. There is always a sense of working against time and temperature. I felt such relief when the often-dripping snowballs had been driven down to the cold stores and had started freezing, safe until it was time for them to be transported south.

Journeys are very much part of the snowball project. Snow makes a journey from the sky to the ground before melting into rivers. My snowballs will come down from the Scottish Highlands in the north, following the route of winter. Many of the materials inside the snowballs resonate with other journeys made to the south – sheep, cows and grain.

The snowballs were made far from the comfort and control of a studio, sometimes in very difficult conditions: driving snow, sleet and rain. I was often very tired and their making was a real struggle. The snowballs were constructed, not rolled. The way that the materials were layered into each snowball will affect dramatically the way they reveal themselves during the melt. I was constructing time and snow. At best, the materials should feel as if they are growing out of the snowball. The time taken in the making will be evident in the course of the melting, as the contents appear layer by layer. The cow hair and the sheep's wool were laid into the snowballs so that when they melt the material will remain connected to the snow for as long as possible. Inevitably the sheer size of the balls and the constraints of time prevented me from making them exactly as I wanted.

I visualised the amount of materials put into each ball as a throw. Imagining them suspended in air helped me to understand the way they occupied the space and volume of the snowball. I will only know if I have achieved the right proportions of materials to snow when it comes to the melt.

Weather conditions will dramatically affect not just how long each snowball takes to melt but the way this happens. If it is dry and sunny, the snowball containing wool could be illuminated like the sun during an eclipse. Wind may blow the wool around like snow. Rain would make the wool hang from the snowball as if from an animal. Different weathers will produce different qualities in each snowball.

Some snowballs contain seeds which will be released during the melt in what could be seen as a hopeless attempt at growth in a built-up environment, but is meant as an expression of nature's tenacious ability to re-colonise a city – to find cracks and openings into which a plant can throw down a root. On a recent trip I made to New York, one of the most impressive sights was a small tree growing out of the side of a building just opposite my hotel room on Broadway, nineteen floors up! Originally, I had intended that all the snowballs would be filled with seeds, in the hope that the people who collect them would be encouraged to plant them – a growing extension of the project – but this became too loaded with complications.

As Conrad Bodman and I searched for sites for the snowballs in the City of London, I began to realise how layered with associations to commerce, trades and agriculture, the area is. The street names around the Barbican contain a sense of what has been there. Midsummer Snowballs will obviously be an ephemeral work, and might be thought of as the antithesis of a built environment. And yet buildings, which people usually think of as solid and permanent, may also change or disappear. Over the last year one of the places we had chosen has vanished. Others are on the point of disappearing. In my own life there are schools I have attended, houses I have lived in, that have gone. The older I get the more I realise how fluid an urban environment is.

The more I explored, the more connections began to suggest themselves between the snowballs' contents and the sites. Most of the snowballs will still feel randomly placed, but some will make specific links to their surroundings. That is an unexpected dimension to the project.

Smithfield Market has become a focus for several snowballs – the cow hair, barley, barbed wire and metal, which will suggest the link between the rural and the urban – a reminder of the land and agriculture upon which a city depends for food.

I have walked around the same streets so many times, and then seen a place that I had not noticed before, as if it had been hidden to me. I now know the sites in a way that makes me think I could have made better use of the connections between place and snowball. I am not saying this would have resulted in a better work, in fact it would probably have made for a worse one. Unexpected and chance links are important. There would probably have been something irritating about, say, putting a milk-filled snowball on Milk Street.

My art is an attempt to reach beyond surface appearances. Nature does not stop or start at the boundary of a city. I want to see growth in wood, time in stone, nature in a city. I don't mean a city's parks, but the earth upon which it is built, the stone with which it is made, the rain that falls on both field and pavement, the people moving around its streets. I dislike the way that nature is perceived by some as peripheral to and separate from the city. I resent the way in which the countryside has been marginalised, considered as a pleasant and recreational backdrop to relaxing at the weekend or on holiday, while life in the city is somehow thought to be more real. In fact, life in the countryside is at times harsh, aggressive, powerful and destructive, as well as beautiful. Working there can be hard work, stressful and traumatic as well as deeply satisfying. Part of the reaction to the snowballs is likely to be a sense of shock and bewilderment provoked by the feeling that nature has emerged in a place where it doesn't belong, similar to the reactions when a heavy snowfall brings a city to a standstill. For me, unexpected occurrences of this sort are evidence that nature is never absent, just not seen.

My upbringing five miles from Leeds, with fields and farms to one side and suburbs and city to the other, has given me a strong sense of the connections between these environments. It has also given me an ability to work in both places without, I hope, a romantic view, or a fear of either.

Although the snowballs will all be in very public locations, they have not been made for people. They are about people. This goes beyond just wanting to see the public's reactions to them. I am interested in the dialogue between two time flows. A snowball melting amongst the river of people that runs through a city . . . the ebb and flow as people arrive for work, have lunch, then leave to go home in the evening. Set against all this activity, the snowballs may appear almost permanent as they very slowly disappear. They will become markers to the passing of time – slow and deliberate like the hour hand of a clock – appearing hardly to move.

The snowballs need the movement of people around them to work, but they are also exploring human presence and absence. In this respect they are similar to my body shadows.

I hope that the melt will begin in time for the morning rush hour. The snowballs will be white at first with little indication of what is contained inside. By the time people

take their morning break, the contents will have begun to emerge and by lunch-time the structure and rhythm of the melt will have become established. As people leave work, debris will have begun to be disgorged on to the street. This is the audience the snowballs are aimed at and whose daily rhythms are in counterpoint to those of the snowball.

Allowing the snowballs to melt on the steet is very different to putting them into a gallery, which by comparison is dead, somewhat timeless, space. People who work in the city will see them over a period of time and really get a feel for the changes that will happen. I am not a performer, but occasionally I deliberately work in a public context.

Concealment is very much part of this project. Most obviously, the contents within each snowball and the placing of some of them in less public locations. Also the manner of their installation – at night when the city is quiet. It would have been so easy to sensationalise the project by mixing deliberately provocative materials into the snowballs. I enjoy working in a quiet and subversive way.

I am often asked if I make the work for myself or for others. I usually reply that I make it for myself, because that feels closest to the truth, but I have never felt entirely comfortable with this response. The relationship between the public and the artist is complex and difficult to explain. This became clearer for me through my collaboration with Régine Chopinot. We worked on a dance, *Végétal*, over the period of a year or so, then we had two weeks of rehearsals. I expected the opening night to be similar to the rehearsals but the difference between a theatre with and without an audience is enormous. There was a palpable critical energy created by the presence of the audience, which made me see the dance with fresh eyes. Its weaknesses were exposed. There is a fine line between using this critical energy creatively and pandering to it.

Unfortunately, the snowballs that are in the most public places will probably not last very long – their lives may well be cut short by drunken snowball fights or whatever. Our urge to make snowballs is matched by our urge to destroy them.

I have to accept the possibility of destructive responses as part of the project. Some snowballs will, however, be placed in protected sites in courtyards and behind existing fences. I like this untouchable quality, reminiscent of freshly fallen snow before it is trampled upon. The garage on St. John Street where the barbed wire snowball will be is a place that nobody is allowed into. In Charterhouse Square, which isn't open to the public, there will be a pair of snowballs – sheep's wool and crow feathers. Not being able to touch is sometimes as interesting as being able to touch. Although they are not intended to be representational, some of the snowballs have a kind of animal energy. Not just because of the materials inside them, but in the way that they appear caged, captured. A layer of fencing between the viewer and the snowball is interesting in the context of a process that is in itself, layered.

It is important that some snowballs are seen to melt away without disruption. I feel as if I am about to scatter seeds of which only a few will survive. Mainly what I will leave behind here is the story of the project.

The red stone snowball that will melt inside the gallery will connect the inside to the outside. The snowball will leave a red stain on the gallery floor, its shadow. Even when those outside have melted and gone, their presence will remain as memories in the places where they stood.

People also leave presence in a place even when they are no longer there. I felt this when walking around the city finding sites. Bunhill Fields graveyard for example, represents the absence of people but also the presence of their memory. At one point, as it began to rain, I lay down until the pavement became wet, then got up, leaving a shadow – my presence. It's the same with the snowballs – they will arrive, then disappear, leaving only intangible memories.

An exhibition is usually the moment when an artist presents something that is completed. But the 21st of June 2000 marks the beginning of this work.

MAKING

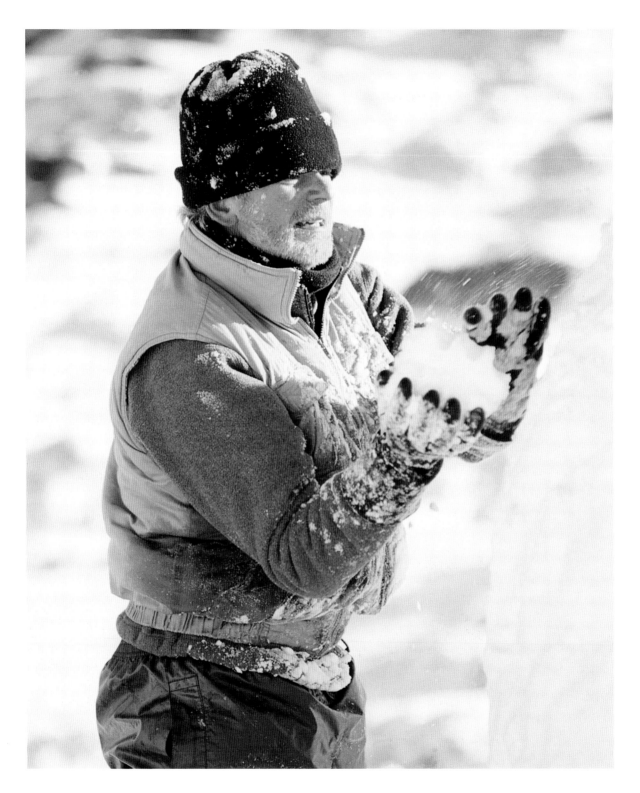

12 January 1999

Finally there is snow! It was forecast yesterday so I was able to prepare for this morning in advance.

Loaded the Landrover and trailer and went to Wanlockhead in the Lowther Hills, north of where I live. On the way, there was snow, but it was wet, so we decided to go higher. I had with me Ellie, Bob Clements and Nick Spencer. There was not an enormous amount of snow on top, but we found one good drift with excellent working snow – not wet, but not too dry either, so we were able to compress it. There is a huge difference between the size of snowball that I made for the 1989 project and the ones I'm making now, for which far more snow is needed.

I may have miscalculated the amount of wool and have had to mix it in rather more thinly than I would have liked. This might add the qualities to the melt that I am actually after, in that the fade from snow to wool should be gradual and subtle.

There were no real problems with the snow or the weather – it was warm and relatively calm. I only managed to make one snowball. I don't think it will be possible to do more in a day. There just isn't the time or energy. So much effort is taken up in the practicalities of driving to the site, making the snowball and taking it to the cold store in Dumfries, where the snowballs are being temporarily looked after by Galloway Frozen Foods. When we arrive at the cold store, it is extraordinary to see the snowball glowing in a largely snowless place; then to see it being lifted off the trailer, carried on a fork lift and put into the cold store itself. There is an enormous sense of relief once it has reached the cold. It looked fantastic amongst all the packing cases containing food. George Adamson, who looks after the cold store, was extremely helpful and although I am sure he doesn't exactly know what I am up to, he seems interested.

If possible, we'll make another snowball tomorrow. I have picked out horse chestnuts to mix into it. The day after the initial snowfall is always tricky. The snow is either thawing or freezing – both conditions that make it difficult to work. Freshly fallen snow is always best. Everybody has worked so well today. I hope it will be the same tomorrow. There is a strong wind this evening, and I think it will be cold and raw.

13 January 1999

It was a much milder morning than I expected after the bitter temperatures of yesterday evening. The snow was thawing. I decided to go as high as possible by road in the hope of finding snow that had not started melting yet. As we went over the Dalveen Pass, the prospects did not look good. There was some snow, but very little that was deep enough to make a large snowball. As we turned up to Wanlockhead, we stopped once or twice where there was snow lying, but it was wet and it would only have been enough to make a smaller snowball. I am having to think about the snow not only as we find it now, but as it may be after several hours of trying to make the snowball. We were not helped by sleet and rain. Higher up we found a fairly deep drift of snow which was good for working. This was what I was looking for – snow that had been kept protected from the warmth and the rain, a quarry from which to extract a snowball.

MAKING

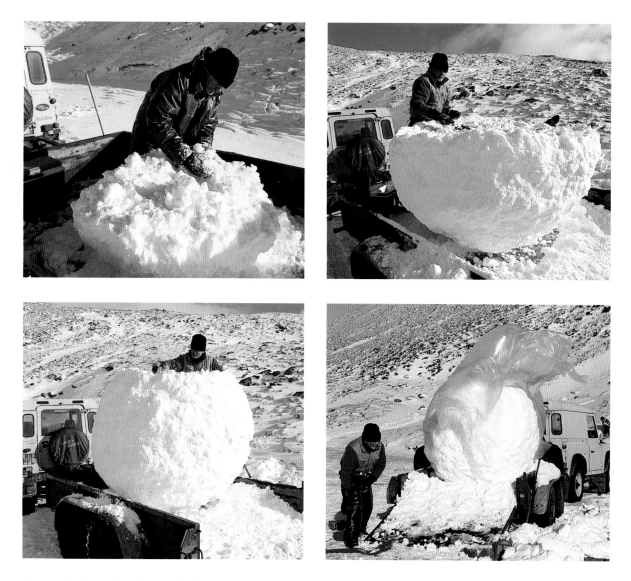

It was windy and wet for much of the time, but without the bitter cold. I mixed in horse chestnuts collected in both England and Scotland. I am finding it incredibly difficult to visualise the melt. I try to imagine the spatial rhythm and placement of the seeds within the snowball, anticipating the melt. Once the nuts have been covered by even a thin layer of snow, it's easy to forget that they're there. I keep thinking of the materials as a throw. I look at the horse chestnuts gathered in the basket and then imagine them thrown into space, trying to understand what I cannot see.

We worked a lot more quickly today, but still not fast enough to come back and make another snowball before nightfall. In any case, I don't think I would have the energy to make two in one day. Apart from being much larger snowballs than I've made previously, much more thought has gone into these and they are proving to be more demanding, both mentally and physically, than the Glasgow snowballs. We will try again tomorrow and return to the drift that we worked at today, but our chances of achieving a third snowball are slight. However, if there is some chance, we should

MAKING

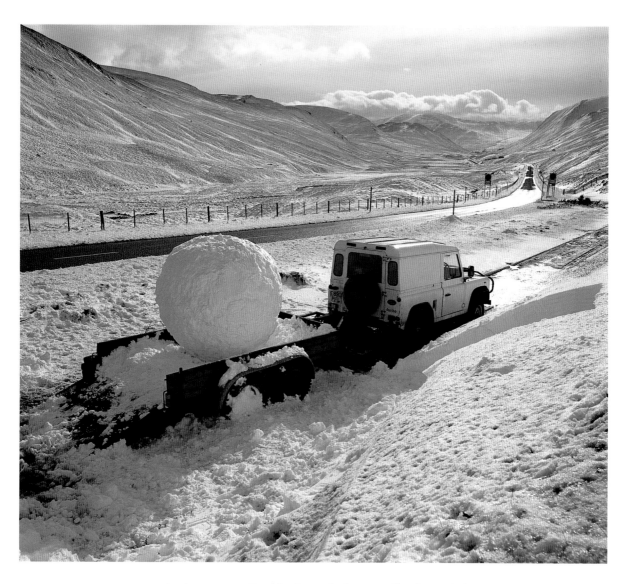

make the attempt. Everybody worked very well today and I have enjoyed the group. Unfortunately Bob cannot make it tomorrow, so I have asked a prospective new assistant who has written to me to come and help. It will be the first time we have met, let alone worked together. I hope that it is not too much of a shock, for someone who knows nothing of my work, for our first meeting to be making snowballs! My attention will be on the making and not on explanations. We will see.

14 January 1999

The snow is disappearing from the low ground. I felt there was only a very slight chance that we would find enough snow today. The ground was bare on the way up the Dalveen Pass. As we turned up towards the village of Leadhills, there was a faint covering of snow which was a hopeful sign that yesterday's snow might not have melted too much.

MAKING

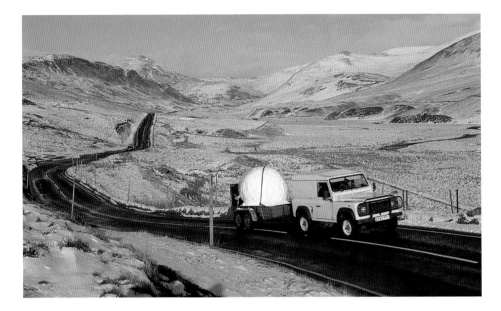

We went to the same drift as yesterday. The snow had frozen hard on top, with a covering of hail stones. I felt that there was enough snow to make a ball, so we began, this time adding ash wings. The snow turned out to be good and workable. When the snowballs are left to melt in the summer, it will be interesting to see if the hail stones melt at a different rate.

It was a very windy day, with occasional squalls of snow. This is the wettest snowball that we have made, and I could see a layer of water at its base. The ash wings were blowing everywhere. It would be interesting if a tree managed to sprout on the place where we made the snowball. It was raining as we left. Tomorrow it is unlikely even to be worth attempting to make another snowball. Not enough snow is left here and there is very little other snow that looks viable. The snow has gathered in this drift because of the lie of the land. It is a perfect place to collect from. I can imagine coming back here again and again. If this does happen, perhaps I could make something to mark the place where the snowballs were collected.

The making today went a little more quickly than before. The difficulty has been trying to mix the seeds or whatever materials we are using in with the snowball. It's hard to introduce materials into the lower half. As the snowball grows larger and rounder, I can build it flat-topped which allows me to lay the materials out on it almost as though it were a table – this helped enormously. As much time is spent putting in the material as compacting the snow.

I am beginning to see some of the snowballs as pairs: sheep and crow; rusted iron and barbed wire; chalk and pebbles; and then the group of seeds. There will be a dialogue and in some cases a drama that will take place during the melt, for which I am laying plans for now – an event that will be prepared for in this century, but which will actually take place in the next. In the end, though, no matter what plans are laid, the outcome will be unpredictable. I think of the snowballs releasing their contents in much the same way as seeds are released from a pod, a process that finds its own course.

MAKING

19 February 1999

I have just returned from a three-day trip to Blairgowrie and Glen Shee to collect snowballs.

Ellie, my new assistant Andrew and I arrived on the afternoon of 17th February. We went up to Glen Shee to see where there might be snow the following day. There had apparently been very heavy snowfalls over the previous week, and we had been told that there was snow on the ground. As we drove up the glen, we saw very little snow and there was none at all at Blairgowrie. It was only when the road reached its highest point that we came across workable snow, where it had drifted and formed quarries which we could work.

The next morning we got up early and left Blairgowrie at about 6.30 am. It was a long, slow drive with the trailer on the back of the Landrover. We found a snowdrift near to the ski resort and began to make the snowball. The weather was damp and warm, so the snow on the surface was not in great condition, but deeper down inside the drift it was good and workable. I mixed in pebbles collected from the Scaur river and finished just after midday.

The journey to Dundee where the Christian Salvesen cold storage facility is located was in some ways more difficult than the making of the snowball. There was a lot of weight in the snow and this, combined with the stones, added up to quite a trailer load for the Landrover to pull. The road is very narrow and windy in places with a bumpy surface which made for difficult driving. We had to stop several times to tighten the straps securing the snowball.

Eventually we arrived at Dundee and, after some difficulty in getting the right equipment, we managed to unload the snowball and put it into the deep freeze. We then returned to Glenshee to make another snowball.

This time curved beech branches were added. In many ways, this was a very enjoyable snowball to make. It was a bonus to be able to tackle a second in one day, and we did

it in the spirit of giving it a try, but not expecting to succeed. The snow was wet and the snowball was made in fine drizzle. In a sense, the curling and folding of the sticks as they were enclosed by the snow anticipated its melt. With the stones and smaller materials it has been very difficult to know how the snowballs will melt, but with this one, you could visualise what is going to happen. We finished in the late afternoon and as it was going dark we set off back to Dundee.

We arrived at the storage depot just before 7 pm. To my horror, large cracks had opened up in the snowball, perhaps connected with its contents, but certainly brought on by the bumpy, windy and long journey. I managed to fill in the cracks and made good the repair. We then had to get a pallet trolley to fit underneath the snowball so that it could be lifted on to the back of the trailer and then fork-lifted off. When the trolley finally arrived, it got jammed underneath the snowball and would not move. An engineer had to be found to repair it. In fact it could not be repaired and had to be replaced by another one, which also jammed, but we managed to drag the snowball on to it. All this time was being lost while the snowball was melting. But the men at the depot were working with energy and enthusiasm – I could not fault them. I did minor repairs on the snowball, filling in the channels left by the straps, and it was then put into cold storage.

The following morning we went back up to the slopes. The snow had gone from most of the places that we had looked at previously. We went beyond Glen Shee looking for new areas and found quite a good drift near the road. This time I mixed in chalk. I wanted to put this material into a fairly dry snowball, so that the chalk would remain as white as possible. Fortunately it had been cold overnight and the snow was frozen on top and in quite good condition below. Even as we made the snowball it was freezing on its shadow side. This was extraordinary. Usually when it is cold, the snow is too hard or too dry to compact. Here I had fairly good workable snow that was simultaneously freezing. It was a fairly relaxed process for a change, although the sun was out for most of the time, causing one side to melt somewhat.

We finished the chalk snowball and took it to Dundee where we packed and sealed it and the previous two snowballs to prevent evaporation.

Three snowballs in two days was a good result. And we are now well acquainted with the logistics of working here. I feel much more confident now that we have six snowballs in storage, although I may bring the sheep wool snowball out this summer to do a test melt and will then replace it with another containing more wool.

There was not enough snow to make any more snowballs this trip and we had run out of materials to work with so we returned home.

23 February 1999
Up early this morning and left Penpont just after 6 am. Arrived at Blairgowrie just after 9 am and went straight up to the slopes. There was very little snow at Blairgowrie

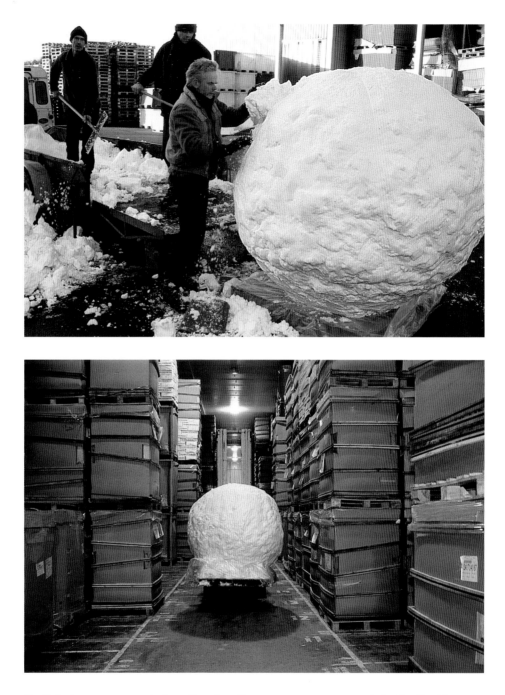

itself, but as we proceeded up the glen, there was more snow and, for the final few miles, it was completely white. Not that the snow was particularly deep, but the strong winds had compacted it into drifts which were perfect for us. When we arrived at the summit, we found deeper snow than we had ever had before. It was tremendously exciting to see so much snow and this combined with the calm, sunny weather lifted our spirits enormously. However, when we began to work and collect snow, we found it to be too dry and impossible to compact. We struggled on for an hour or so, trying to use snow lying close to the ground that was a bit damper. This

was frustrating because the snow was of poorer quality, less white. In the midst of so much snow, we were, in effect, having to search out old snow rather than the freshly fallen.

After a while, I gave up and went looking for alternative places lower down the glen. Found a place which probably would have also been frozen dry earlier on, but with the effects of the sun and the higher temperatures in the valley bottom, the snow there had become a lot more sticky. It was perfect to work with and I would have liked to have made the ground red stone snowball which really needs to be made with dry snow, but I had already begun with the rusted iron one. This contains fragments of metal that I have collected from fields and farms around where I live. These objects contain the memory of the hand and machine that have worked the land and are now in the process of rusting and fading into the earth again. There are bits of fencing, tools, chains, gate hinges etc. When it comes to the melt, they will appear as archaeological objects from a dig. I like the fact that some of the snowballs will contain objects that are very much about the past and others – like the seeds – that are about the future. The chalk, pebbles and red stone will be about the processes of erosion and tension that exist between water and stone – thaw and freeze, winter and summer.

We put the snowball in temporary cold storage at Blairgowrie. This is where I stored the snowballs ten years ago, and there is a certain pleasure in that. The storage facility is no longer owned by Christian Salvesen, but by Scottish Soft Fruit Growers. There were several people there who were extremely helpful, not to mention being very skilled on the forklift. They asked for invitations to the exhibition which I will be only too delighted to give them. The snowball has certainly given them something to talk about. One of the women, who drove the fork-lift, wanted to know precisely how heavy it was so that she could tell her friends that she had put a two-ton snowball into cold storage that day.

The weather today has been glorious. The calm has been quite a relief from the usual wet, windy conditions in which we have had to make the snowballs so far. As we brought the snowball back, it became increasingly cloudy and mild. If it is mild tonight, it means we can get out early tomorrow. Had it been cold again, we would have had to wait until mid morning for the snow to thaw somewhat. As my assistant Ellie said on the way back, we seem to have got each snowball made only by the skin of our teeth. Even on a day like today, with lots of snow, the making, especially to begin with, seemed to be the most difficult so far. Wallace, an old friend from the village where I live, came today along with my other assistant Andrew. It is always good to have Wallace working with me.

24 February 1999

This morning it looked as if the night had not been as cold as forecast. It was overcast and there was little sign of a heavy freeze. However, when we got up to the snow, we found it dry and unworkable. It was several hours before it had thawed enough to compress and even then, the making of the snowball was a long process which took most of the day. Instead of building the snowball up in great blocks of snow, we were constructing it in handfuls. It was a beautiful, sunny day, so bright that my assistant Andrew's eyes became sore and he had to rest for some of the time.

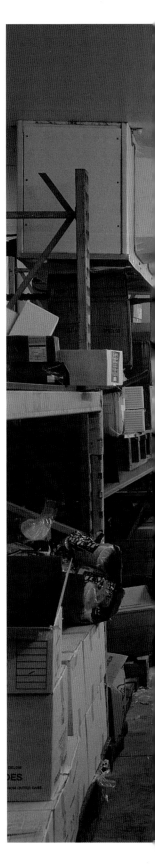

MAKING

We mixed wool into the snowball, a replacement for the first wool snowball. This time there was much more wool laid among the snow in a more considered and structured manner in the hope that when it comes to the melt, the wool will appear to grow out of the snowball.

Each snowball contains qualities of the weather in which it was made. This one contained both the dry, white snow and a calmness from the way it was made and the lack of wind during its construction which allowed me to lay wool on as I wanted. Had it been windy, the laying of the wool would have been a totally different process.

This is probably the last snowball I will make this winter, leaving the remaining seven for next. I am not sure about the problems of evaporation in the cold store and feel it wise to cover myself to some extent by only making half the amount now. If the worst comes to the worst, I'll have seven from next year for the exhibition.

INSTALLATION

21 June 2000, midnight to dawn

We began the installation of the snowballs just after midnight and finished around 6 am. After years of planning and preparation it was a big moment for me.

The trucks that brought the snowballs down from the cold store in Dundee were parked up close to Smithfield Market. The way I had imagined their arrival and distribution was very close to what actually happened: bright lights, dark spaces, machines, people, vague forms visible through the clouds of mist that gushed out of the refrigerated trucks as their doors were opened to the warm air.

I had not anticipated there being such a lot of press and TV present. It was tense, I was tense, especially when it seemed to take forever to get the first few snowballs from the containers onto the flat-bed trucks that would deliver them to their locations.

I enjoyed seeing the snowballs being lifted into place – white spheres suspended in the night sky. Pushing the snowballs off the pallets presented some problems, especially those that had been made with wet, thawing snow which had drained down to the base and frozen solid in the cold store.

There were some incredulous looks from the workers at Smithfield Market and from time to time one or two of them came over to have a closer look. I had no time or energy to give them any attention. The pressure of getting the snowballs placed before most people arrived for work was intense. Timing has been a critical factor at every stage of this project. The installation was carried out in the same spirit in which the snowballs were made – working quickly before the snow thawed.

Meeting the deadline of dawn is not like meeting the deadline of an exhibition opening. Sunrise seems more urgent and final than a date on an invitation card.

The most enjoyable placement of the snowball was at Bunhill Fields cemetery. It was so peaceful and quiet in the graveyard: no film crew, no photographers (other than Chris McIntyre from the University of Hertfordshire whom I know well), just the white snowball and gravestones.

There was a dreamlike, timeless quality to working through the night. Dawn broke almost imperceptibly – it became light almost without my realising it. By then I knew that we would easily finish.

The last snowball (containing barbed wire) proved problematic, because a car had parked awkwardly nearby and the gate to the site would not open, so the snowball had to be lifted over the wall into the space.

Then the covers were taken off, and there were the snowballs! Some had already begun to thaw, but most gave no indication of their contents.

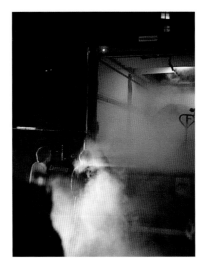

Left
Unloading the snowballs
West Smithfield, City of London
21 June 2000, 1-2 am

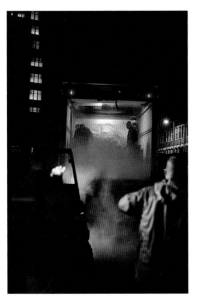
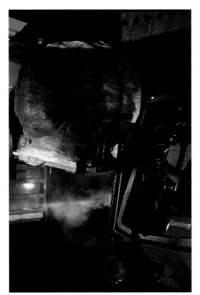

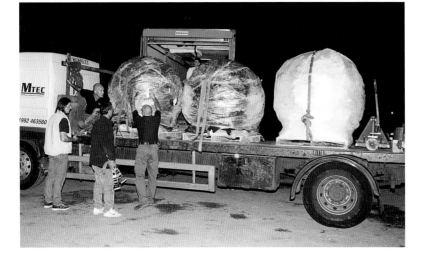

Opposite page
Installing the snowballs
Clockwise from top left:
West Smithfield, Lindsey Street,
Bunhill Fields (two pictures),
St John Street, Silk Street.

Overleaf
Charterhouse Square (*left*) and St John
Street (*right*)

City of London, 21 June 2000, 2-5 am

INSTALLATION

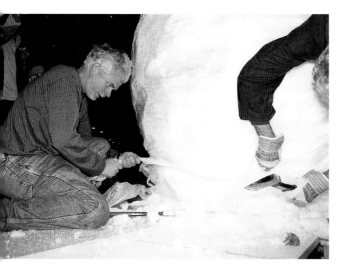
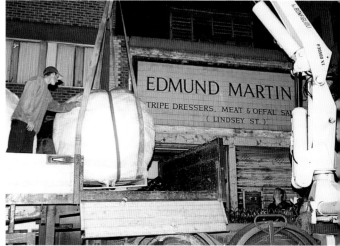
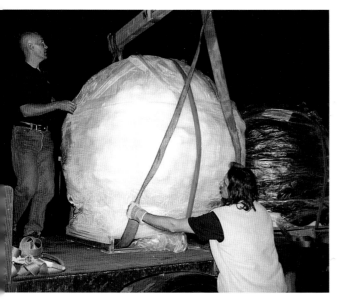
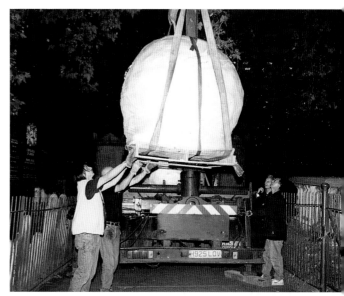
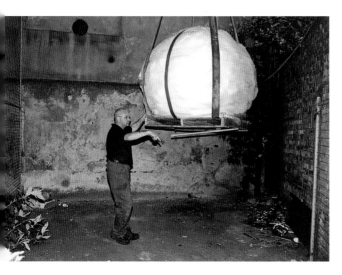
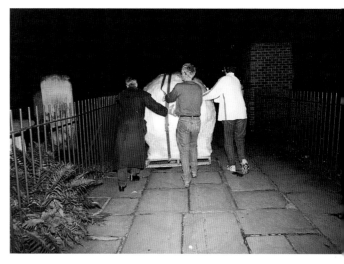

INSTALLATION

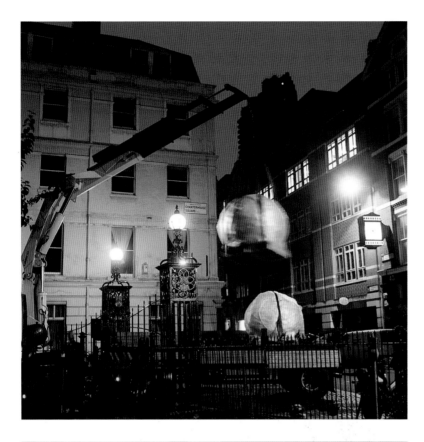
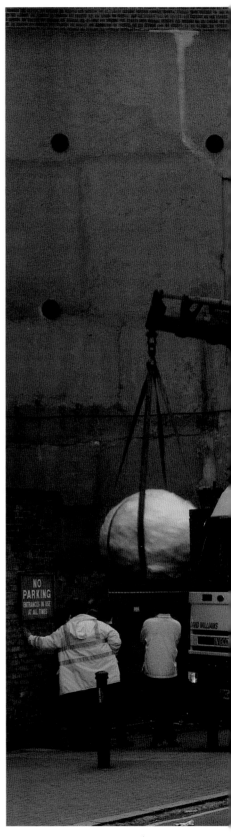
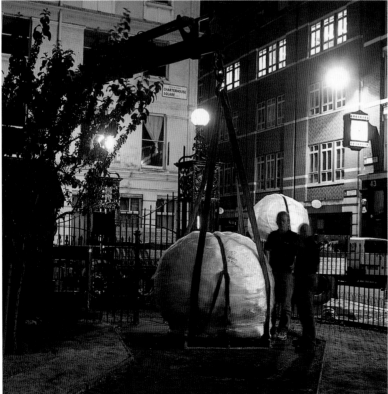

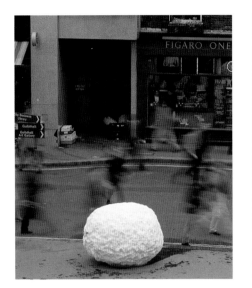
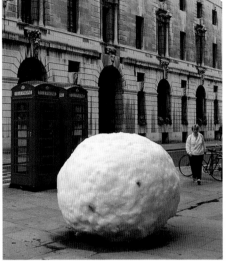
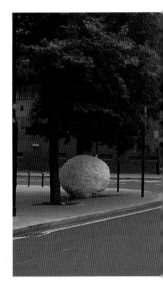

Wednesday 21 June 2000

I was surprised by how some snowballs that I had expected to work well did not and others that I had not been too excited about worked beautifully. The most interesting one contained curved branches that gradually began to appear, to one side at first, as the wind eroded the snowball. A similar thing happened to the snowballs in front of the Barbican on Silk Street, which were undercut at their bases by the wind. In fact, towards the end of the day, one toppled over.

The wind is taking them away more quickly than I had anticipated, especially those made with drier snow. The elderberries have been disappointing. The dryness of the snow, or the fact that it is evaporating as much as melting, or the rapid freezing of the snowball, or a combination of all of these things has prevented the berries from becoming liquid enough to turn the snowball red.

My friend Hervé from Digne arrived and played the saxophone for the snowball with the branches. This was a good moment for me to just sit and listen and enjoy both the music and the snowball.

Thursday 22 June

At about 3.30 this morning, the three snowballs outside the Barbican entrance were destroyed by an angry passer-by. Although the staff at the entrance tried to stop him, he was apparently determined to break them.

I arrived at about 5.30 am to find someone beginning to sweep up the crushed remains. It was a pity these snowballs could not have stood a little longer. The effects of the wind had dramatically sculpted the balls at their bases, making them tall,

Far left
Elderberry snowball, Moorfields

Left
Beech snowball, Finsbury Circus and Moorgate

BEECH

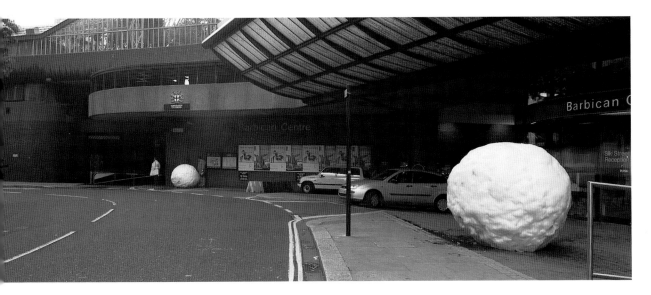

Above

Ash, horse chestnut and Scots pine snowballs, Barbican Centre, Silk Street

City of London, early morning, 21 June 2001

top-heavy and precarious. Their existence had been cut short just before they reached their most interesting stage. Perversely, they were at one of the more secure sites and destroyed at what I would have thought was the safest time of the day or night.

Even though I knew this could happen I am still disappointed. Each snowball has been a risk and any risk taken would be meaningless if when something went wrong there was no accompanying sense of loss.

The wind has prevented materials accumulating on the surface of some of the snowballs, which has given them a somewhat bald appearance.

Other snowballs have been made more interesting because of the wind. The stick snowball continued to be eroded from one side and at one point was suspended above the ground in the branches. Because most of the branches had been worked into the middle of the snowball it kept a strong sense of form even when little snow remained. Only towards the end did the branches collapse into a heap. This snowball had melted completely by the end of Thursday, helped along by people's hands. Although quicker than I anticipated it has had a full and good life.

The elderberry snowball has also gone and was a crushed heap this morning. Less interesting.

Although most of the seeds were swept up in front of the Barbican, I found some at quite a distance from the site where their snowballs melted – caught in cracks in the road and pavement.

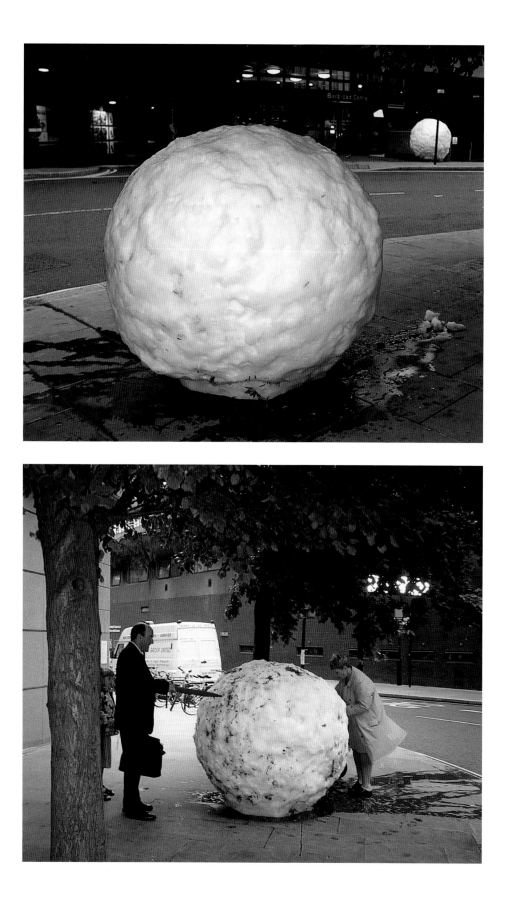

ASH

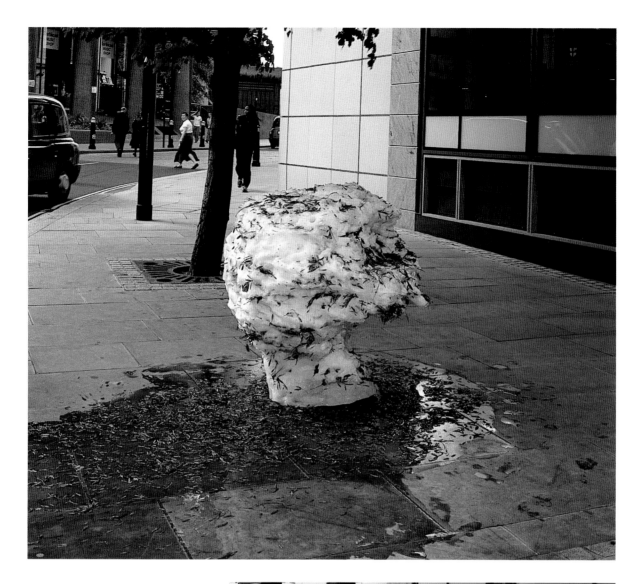

Ash keys

BARBICAN CENTRE, SILK STREET

Morning to afternoon

21 JUNE 2000

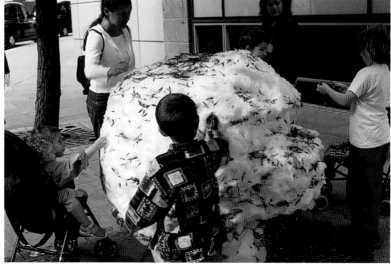

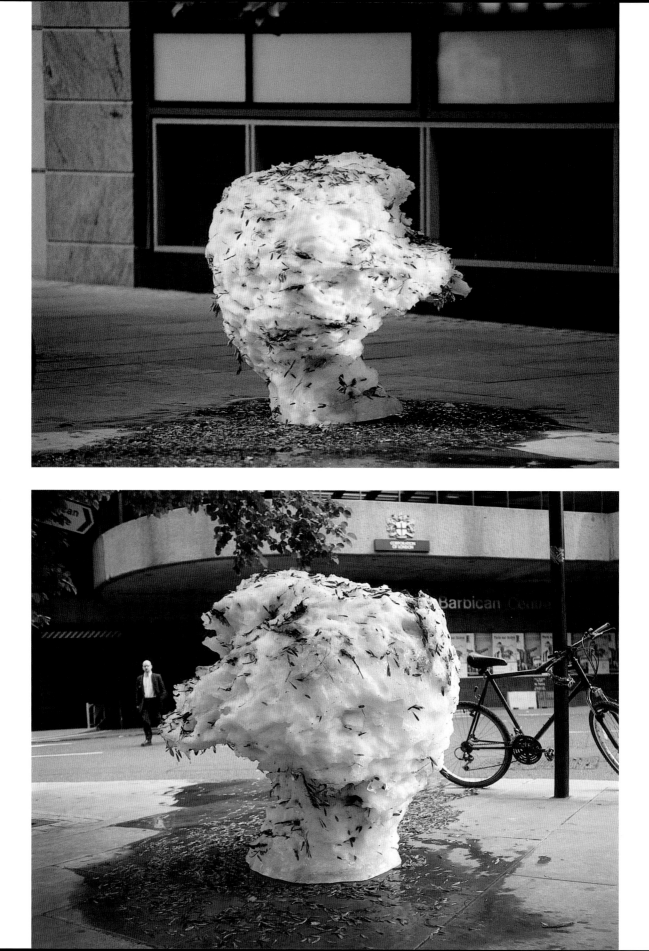

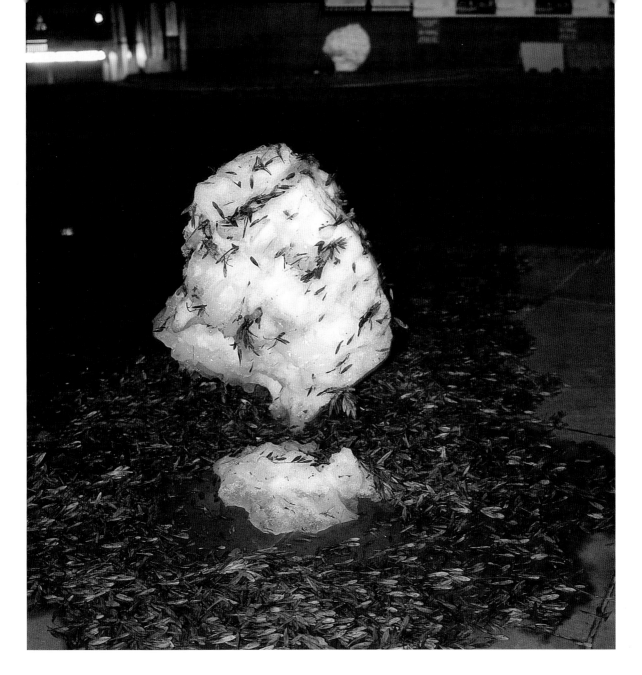

ASH

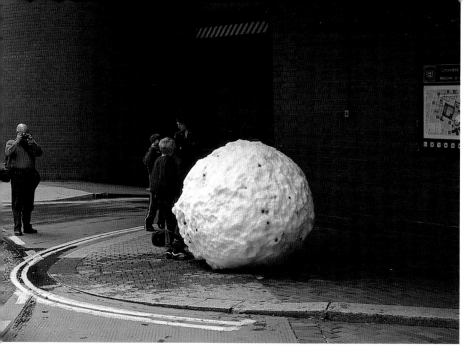

Horse chestnuts

BARBICAN CENTRE, SILK STREET

Morning to afternoon

21 JUNE 2000

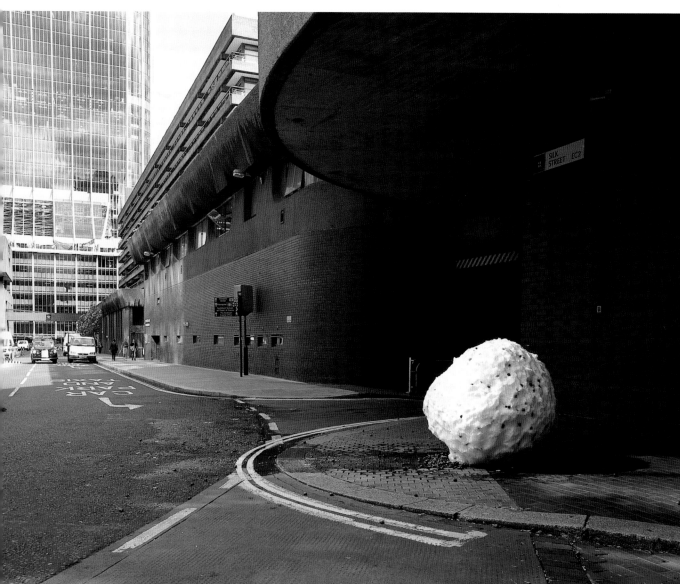

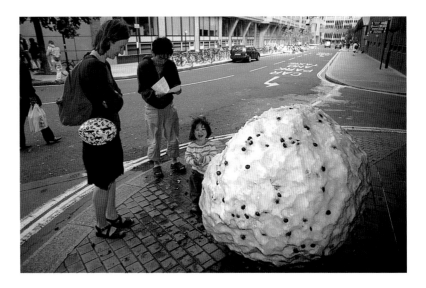

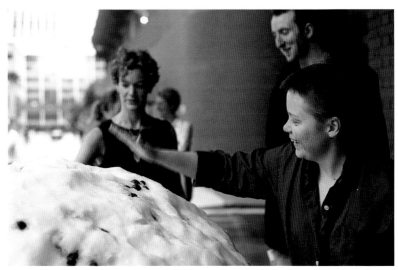

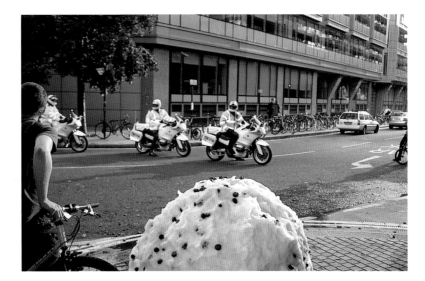

HORSE CHESTNUT

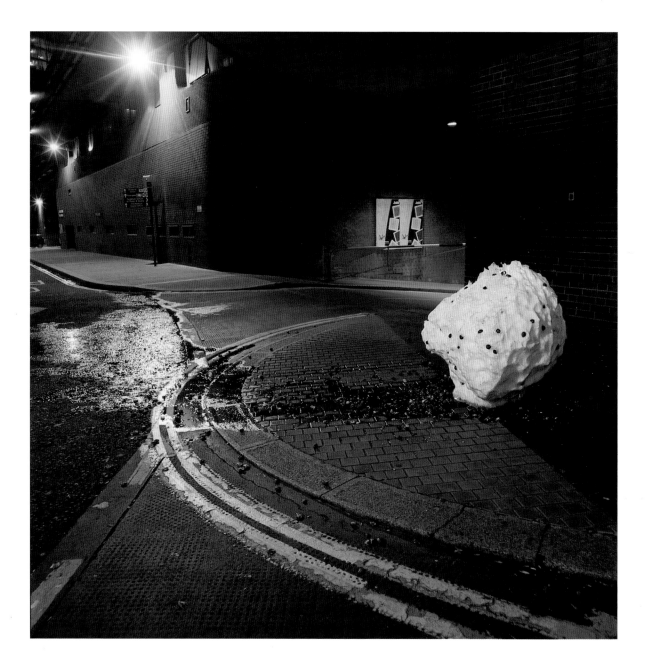

Late evening

21 JUNE 2000

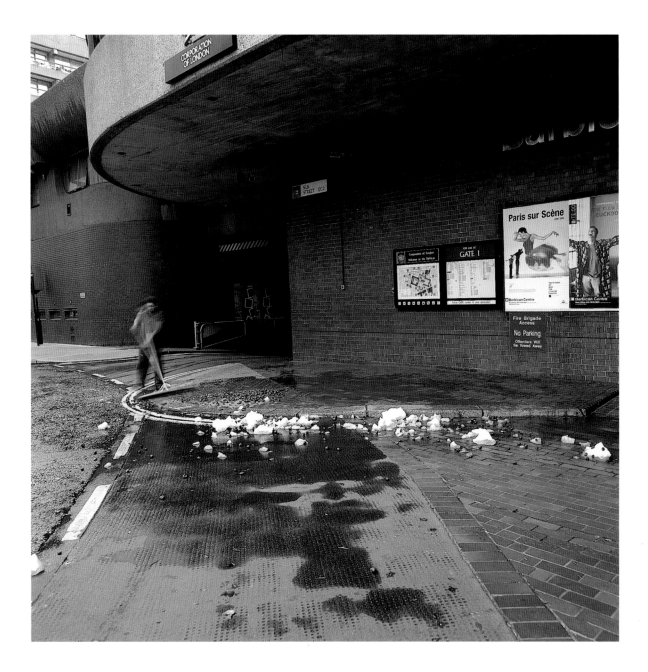

Early morning

22 JUNE 2000

HORSE CHESTNUT

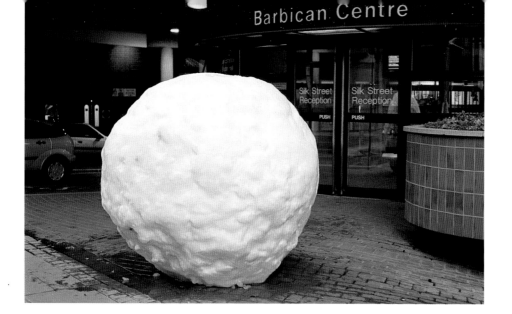

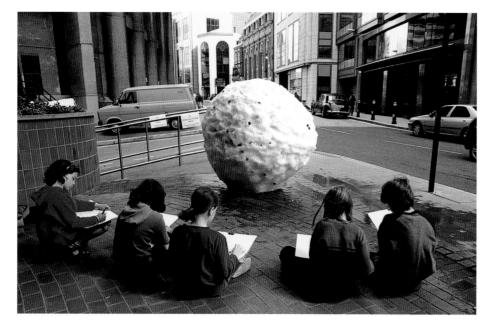

Pine cones

BARBICAN CENTRE,
SILK STREET

Morning and
afternoon
21 JUNE 2000

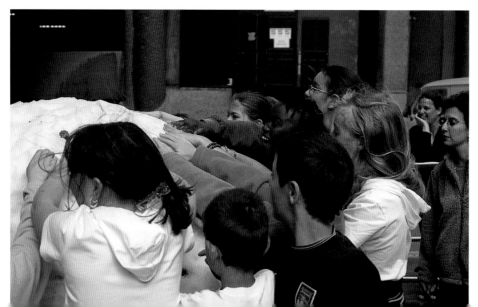

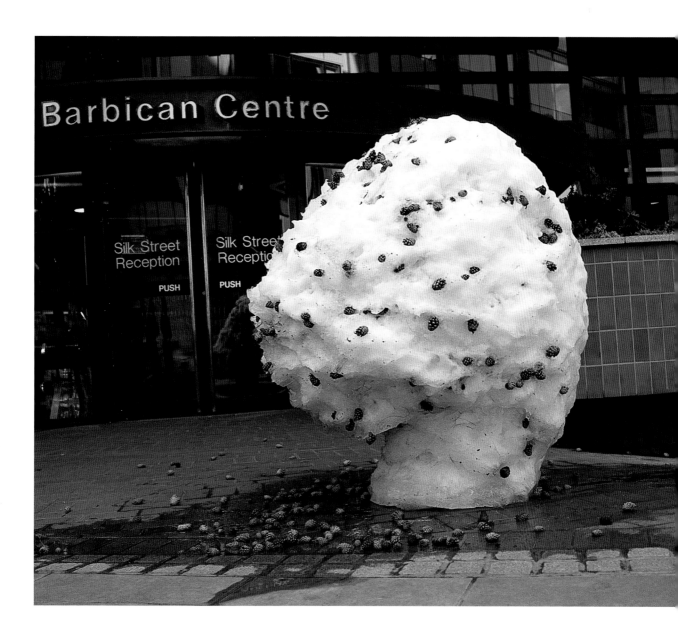

Early evening

21 JUNE 2000

PINE

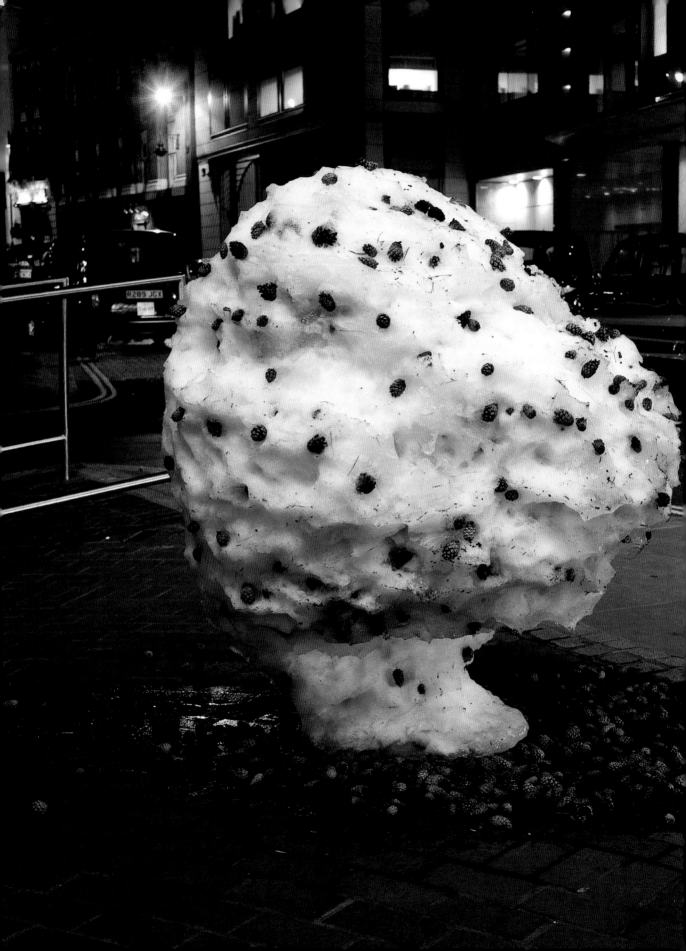

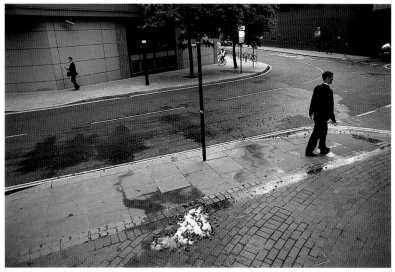

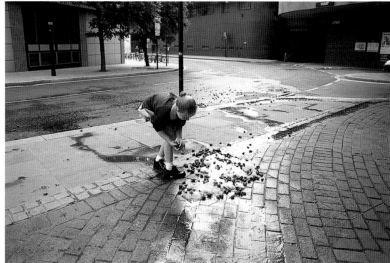

Left
Late evening
21 JUNE 2000

Above
Morning
22 JUNE 2000

PINE

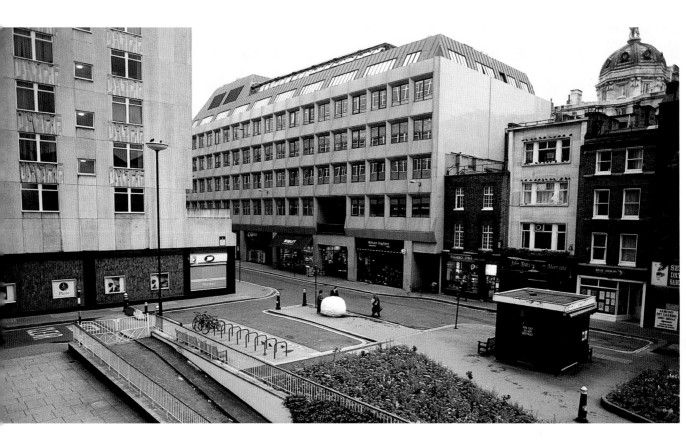

Elderberries

MOORFIELDS

Morning and afternoon

21 JUNE 2000

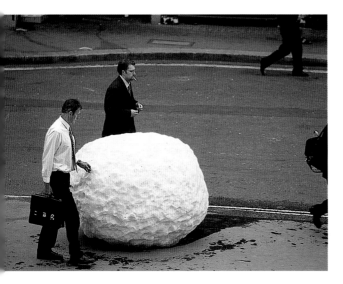

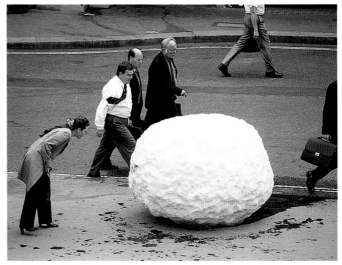

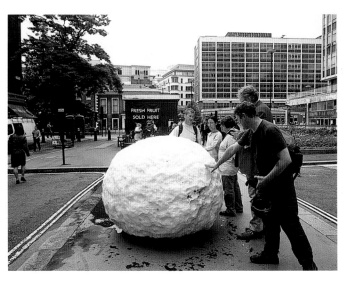
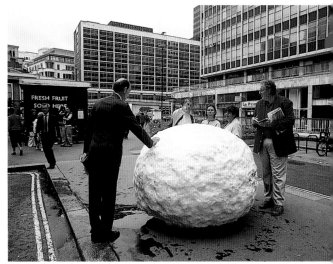
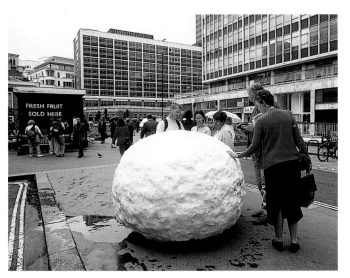
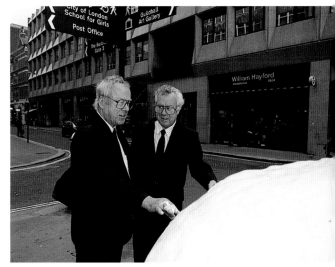
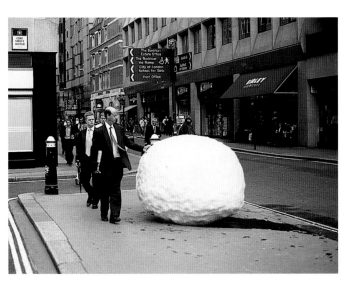
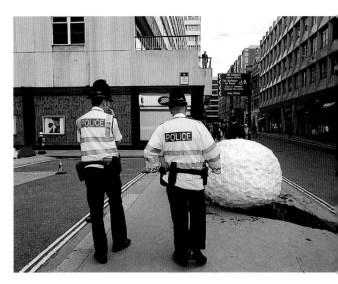

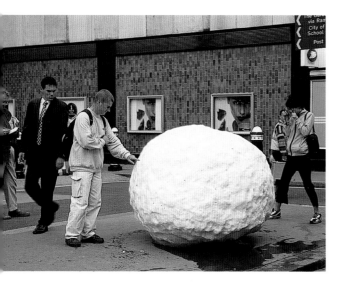
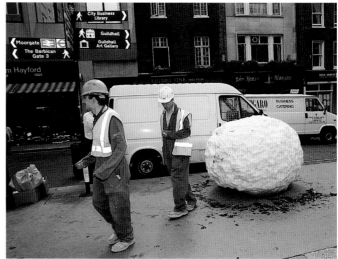
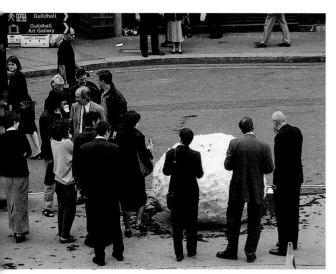
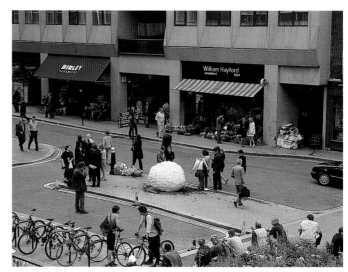
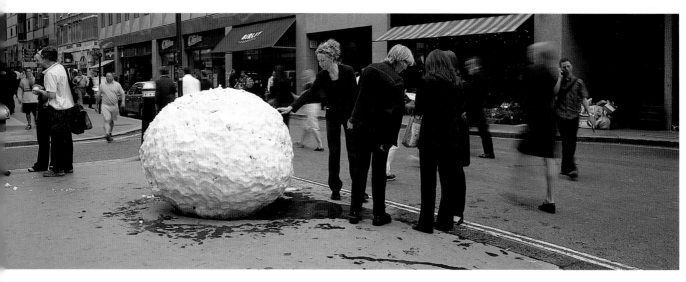

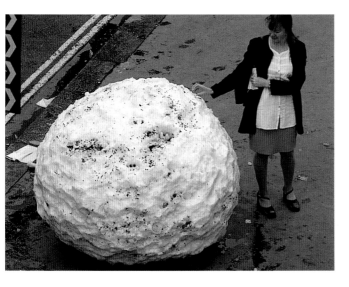
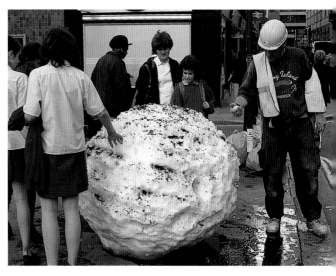
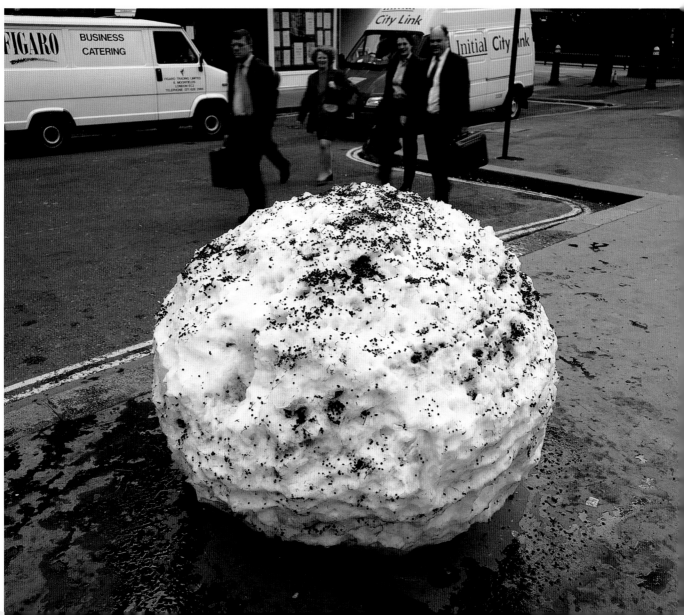

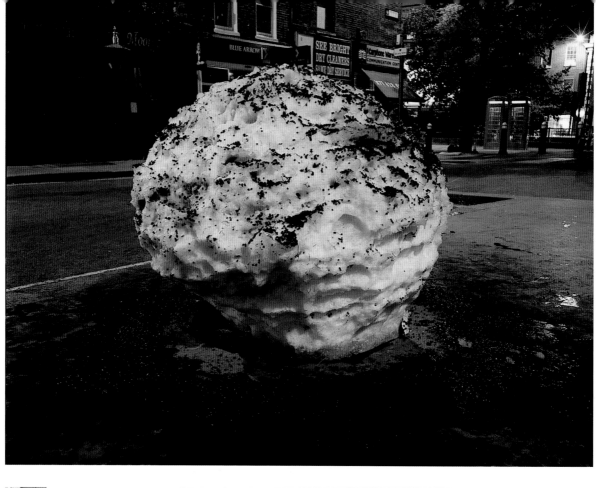

Opposite
Night
21 JUNE 2000

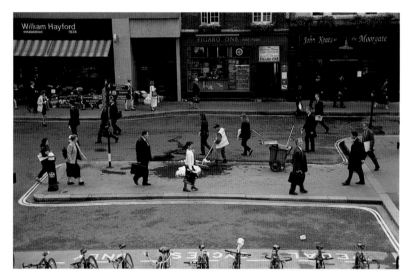

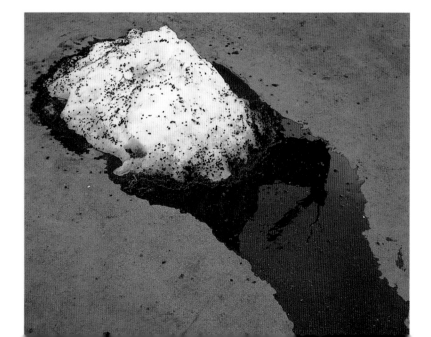

Opposite, below, and this page
Morning
22 JUNE 2000

71

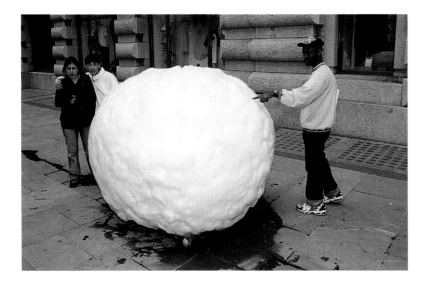

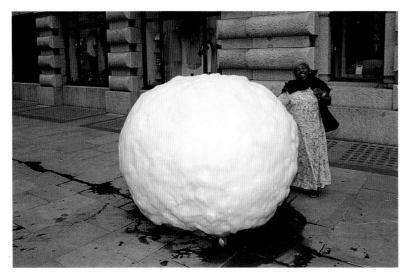

Beech branches

FINSBURY SQUARE & MOORGATE

Morning to early afternoon

21 JUNE 2000

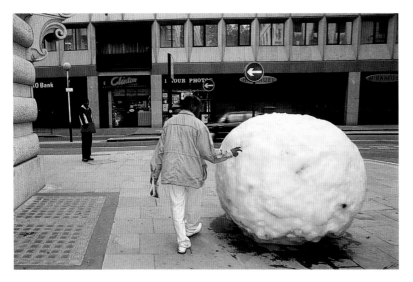

BEECH

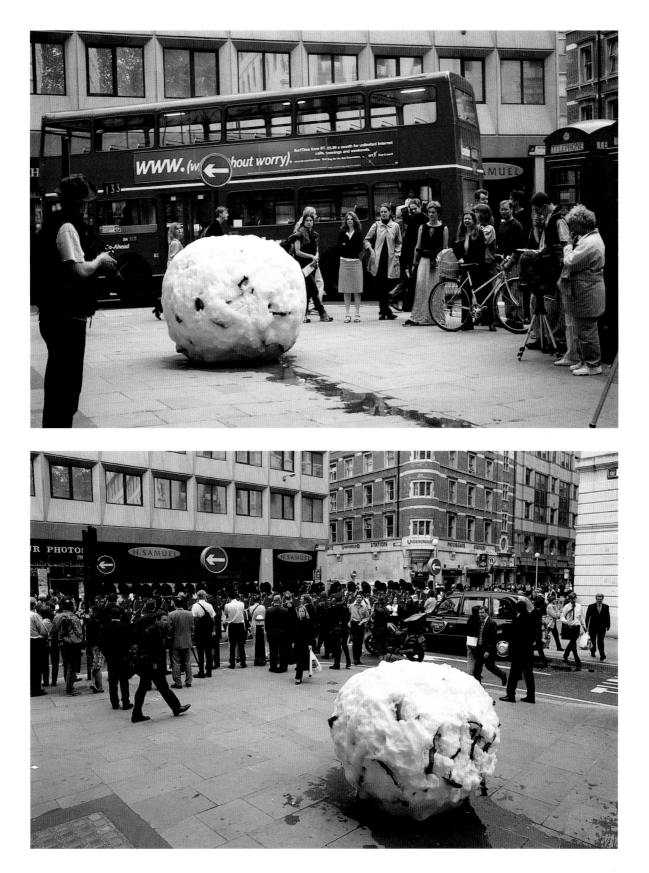

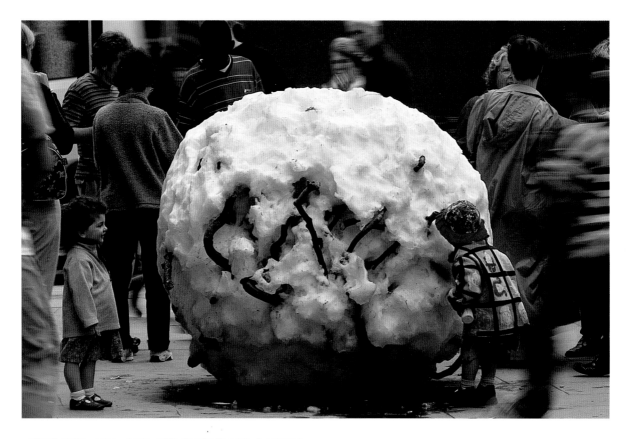

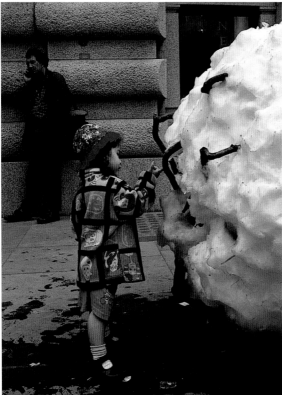

Early afternoon

21 JUNE 2000

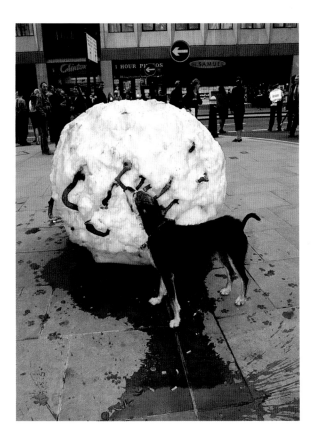

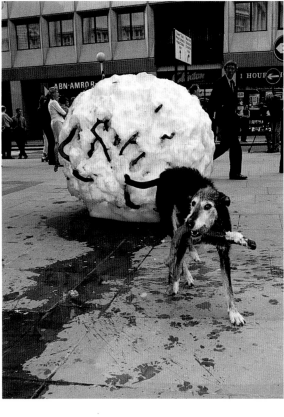

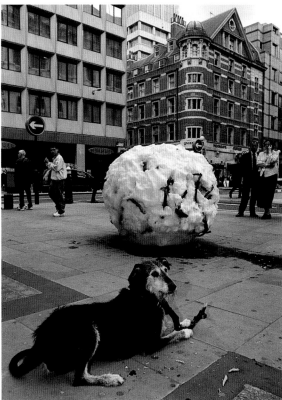

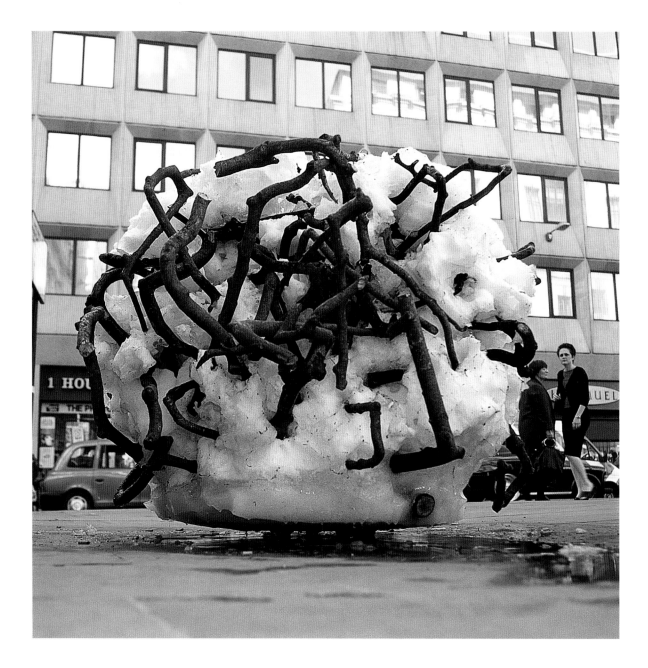

Late afternoon

21 JUNE 2000

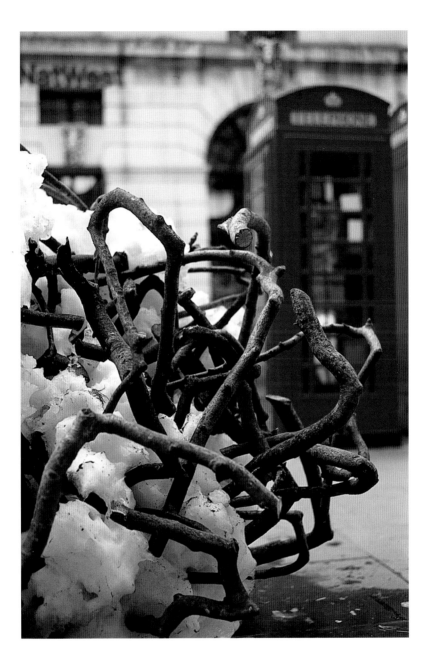

Late afternoon

21 JUNE 2000

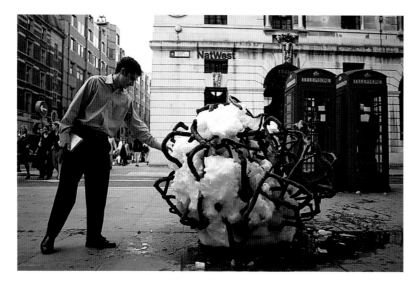

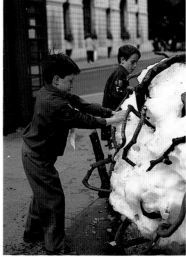

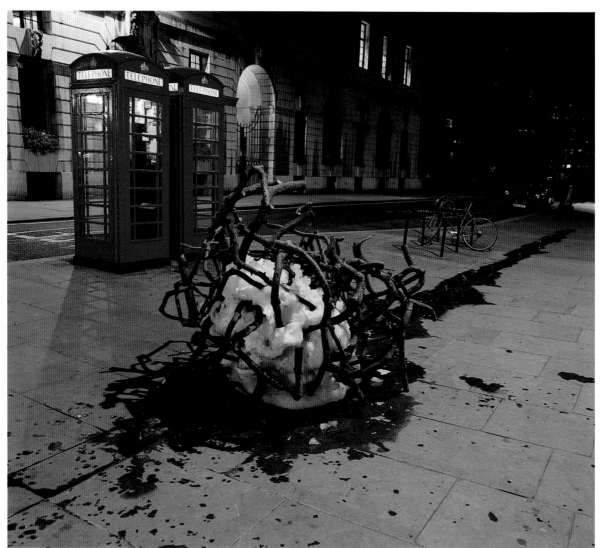

BEECH

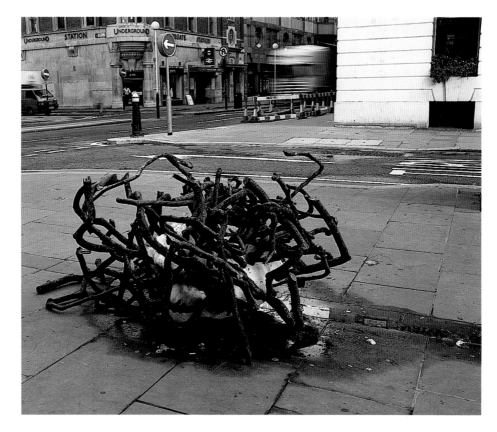

Opposite page, above
Evening
21 JUNE 2000

below
Night
21-22 JUNE 2000

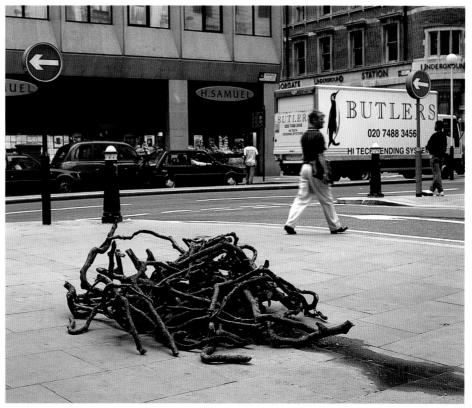

This page, above
Morning
22 JUNE 2000

below
Afternoon
22 JUNE 2000

BARBED WIRE BARLEY METAL

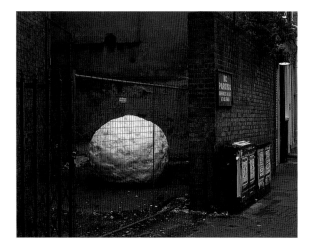

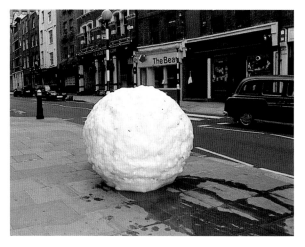

Wednesday 21 June 2000

Some of the snowballs are changing dramatically as they thaw. The barley has become much stronger in the course of the day. Pigeons have been attracted to the grains as they have collected on the pavement. I like the idea of a snowball's contents being eaten and flying away.

The snowball in the tripe shop is also melting slowly, revealing its contents in a strong and interesting way. I'm protecting this snowball so that the debris can remain part of the piece. The building is closed up at night and there is someone in attendance during the day. Some bits of metal have dropped off, and others are cradled within cavities that have formed in the snow around them.

At lunchtime, Hervé (my friend the saxophonist) came and played for this snowball. The acoustics in the room were surprisingly good.

The barbed wire snowball is becoming animated by the coils of wire surrounding it – more or less as I anticipated, which is certainly not the case for many of the others.

Thursday 22 June

The barley snowball has fallen over and is thawing rapidly. It's difficult to understand why one snowball such as this melts so quickly, while another, like the cow hair, doesn't. The hair and wool must act as insulation. The barley snowball was made with very wet snow, and consequently should be one of the densest and yet it is now almost gone. Possibly chunks are being taken away, I don't know.

A barmaid from a nearby pub came out to tell me how she first saw the snowball out of her bedroom window and of the increase in business at the pub because of snowball watchers. This morning she had seen a flock of twenty pigeons around the ball. I would love to see that and will return first thing tomorrow.

Left
Barbed wire snowball
St John Street

Above
Barley snowball
Long Lane &
Lindsey Street

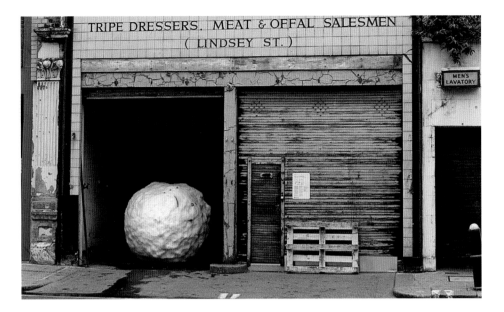

Metal snowball,
Lindsey Street
City of London
morning, 21 June 2000

Friday 23 June

There was very little of the barley snowball left this morning. Several pigeons were feeding on the remains. They are attracted especially to the grains that have been crushed by people walking or cars driving over them, which means that they tend to pay most attention to the ears of barley scattered some distance away from the spot where the snowball melted. By mid morning, the snow had gone and to my surprise, when I returned, so had the barley. Apparently a road sweeper had come along and swept it all away.

The most beautiful moment for me today was seeing among the coils of barbed wire a tiny brilliant white piece of snow, just as I had hoped. It looked so fragile – protected by its mass of barbs.

The metal-filled snowball continues gradually to melt. There are possibly one or two days' more melting to go. Hervé came again to play to the snowball. I have so much enjoyed his music. It has given me a chance just to sit and listen and think – almost falling asleep sometimes, I feel that tired.

Saturday 24 June

The barbed wire ball is now completely free of snow, but still looks alive with movement.

In order to see the metal snowball I have to lift up the shuttered door to the building that contains it. I always feel a sense of anticipation about what lies behind. The quantity of water draining under the door on to the pavement is an indication of how much snow is left. This evening the pavement was almost dry – a sign that the snowball is getting much smaller. There is, however, still enough snow left for it to remain for at least two more days.

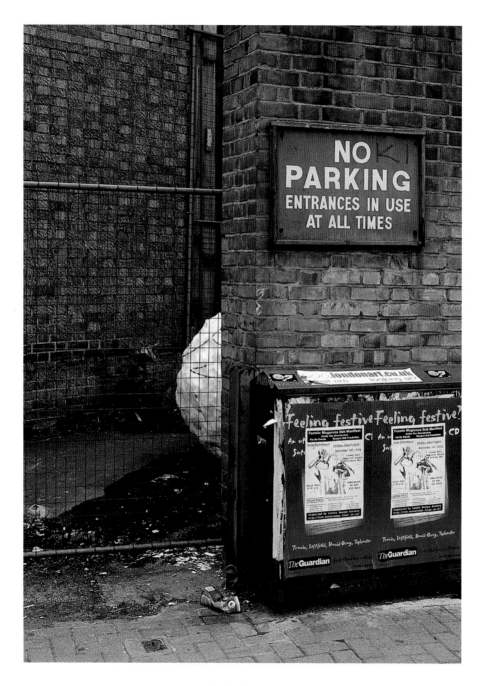

Barbed wire

ST JOHN STREET

Morning to afternoon

21 JUNE 2000

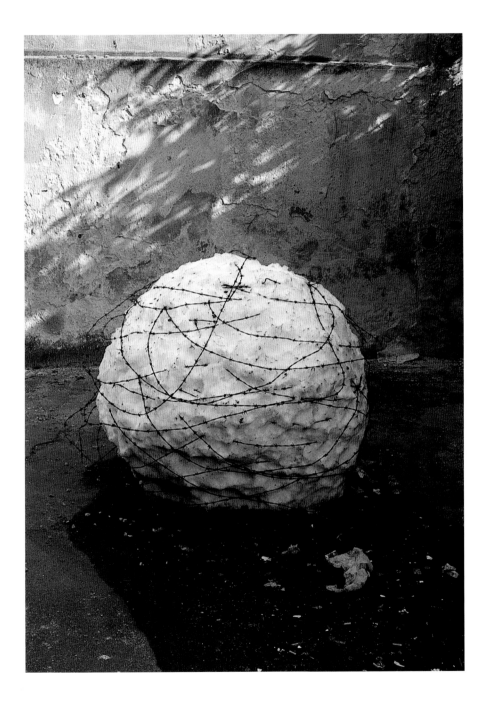

BARBED WIRE

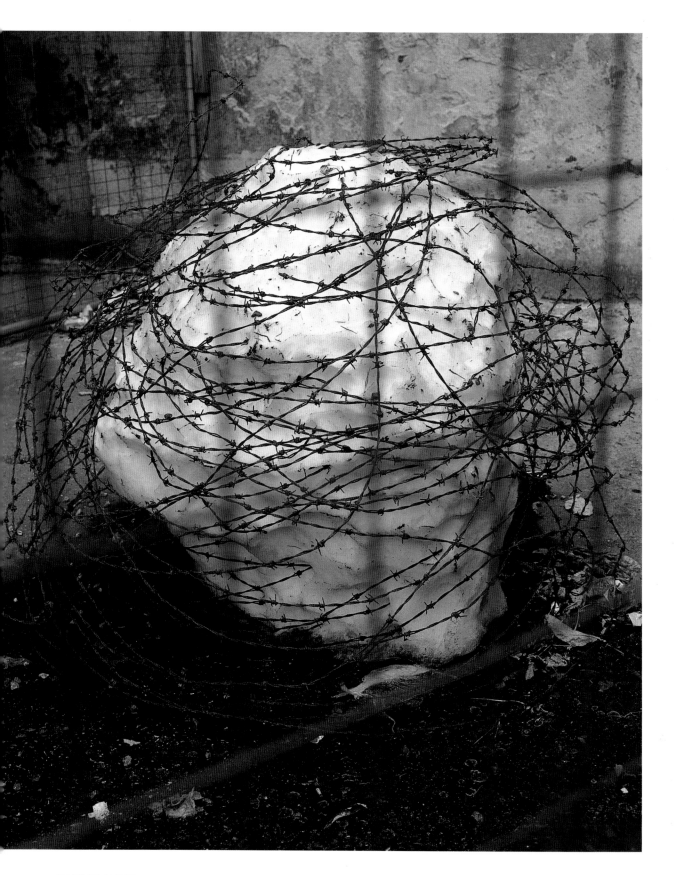

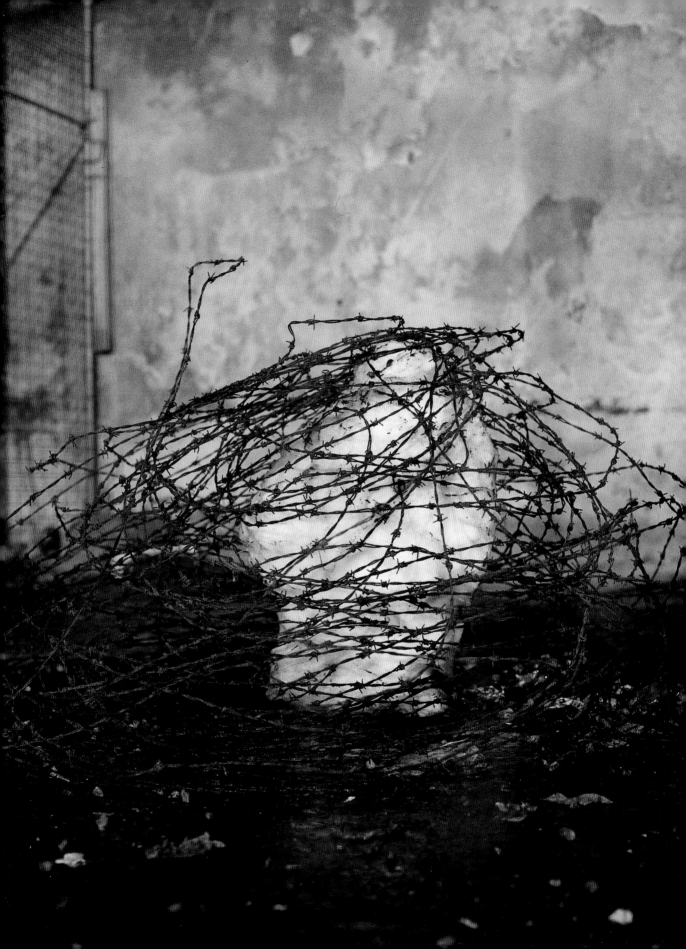

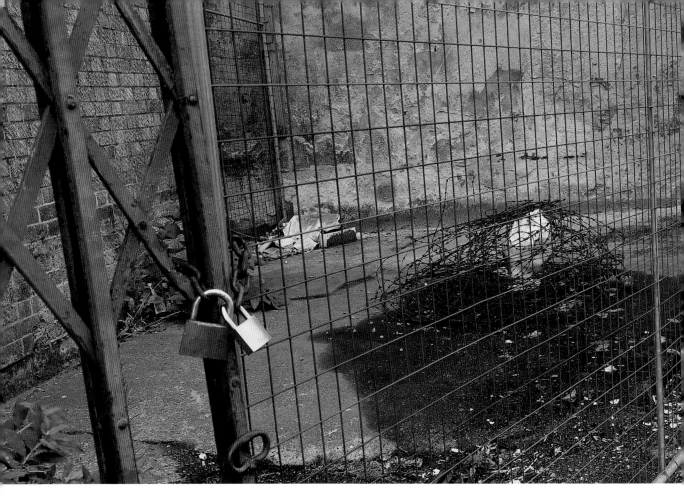

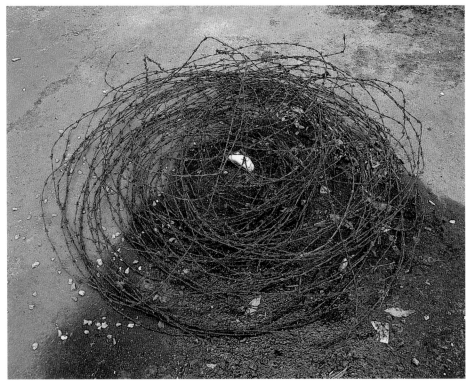

Above

Afternoon

22 JUNE 2000

Left and opposite

Morning

23 JUNE 2000

BARBED WIRE

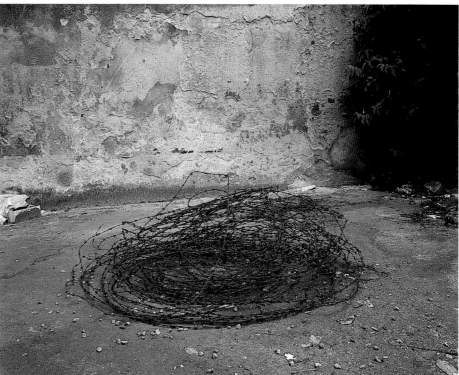

BARBED WIRE

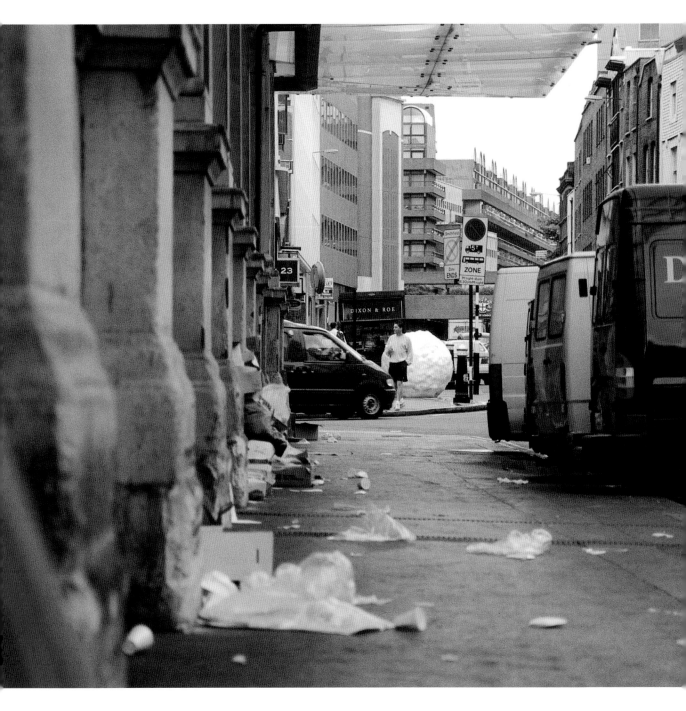

Barley

LONG LANE & LINDSEY STREET

Morning

21 JUNE 2000

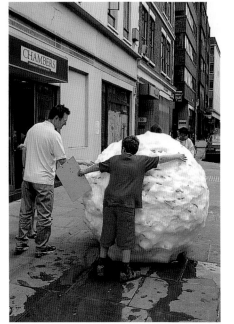

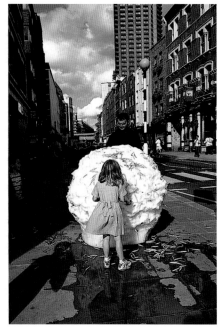

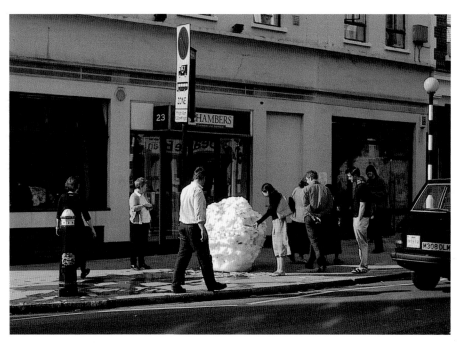

Afternoon

21 JUNE 2000

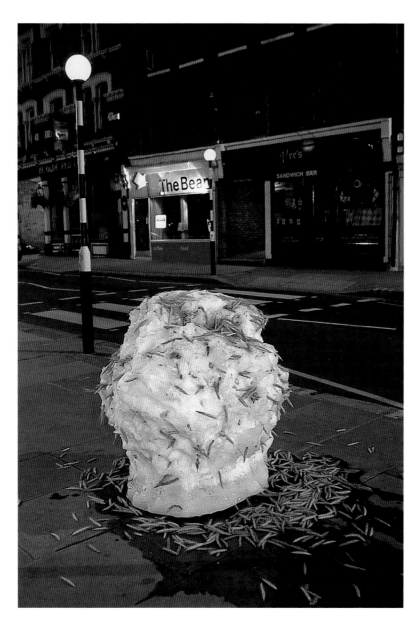

Above
Night
21-22 JUNE 2000

Right
Morning
22 JUNE 2000

BARLEY

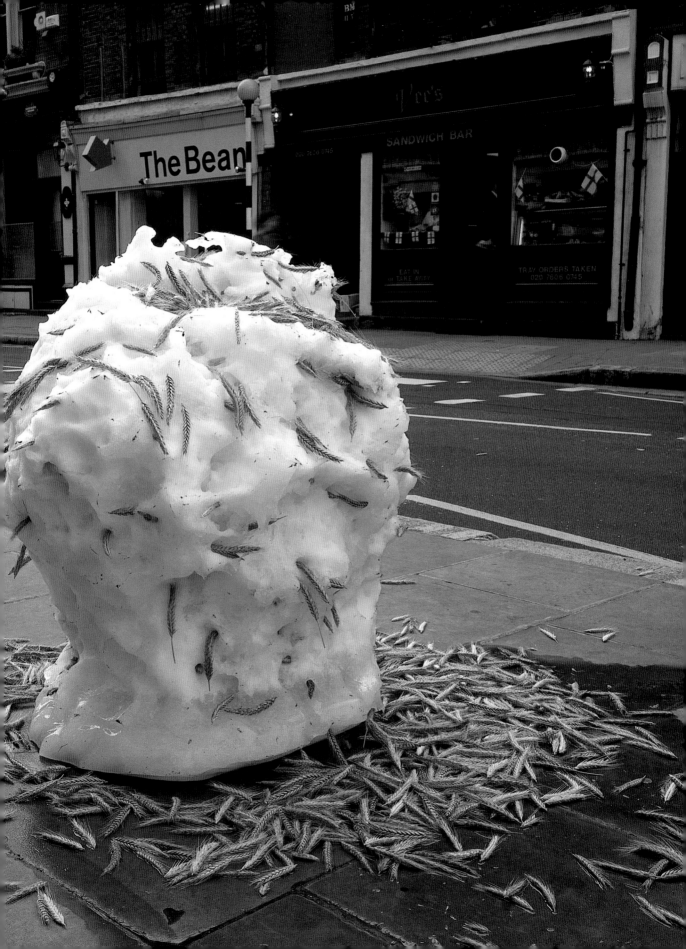

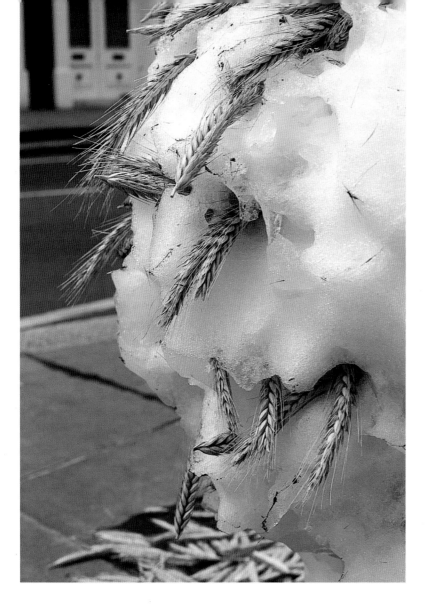

Morning to morning

22-23 JUNE 2000

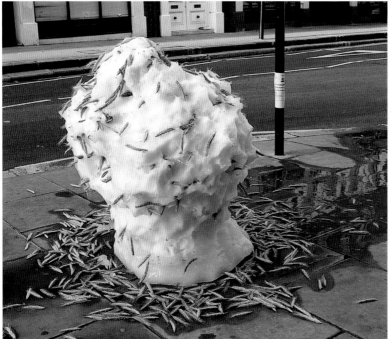

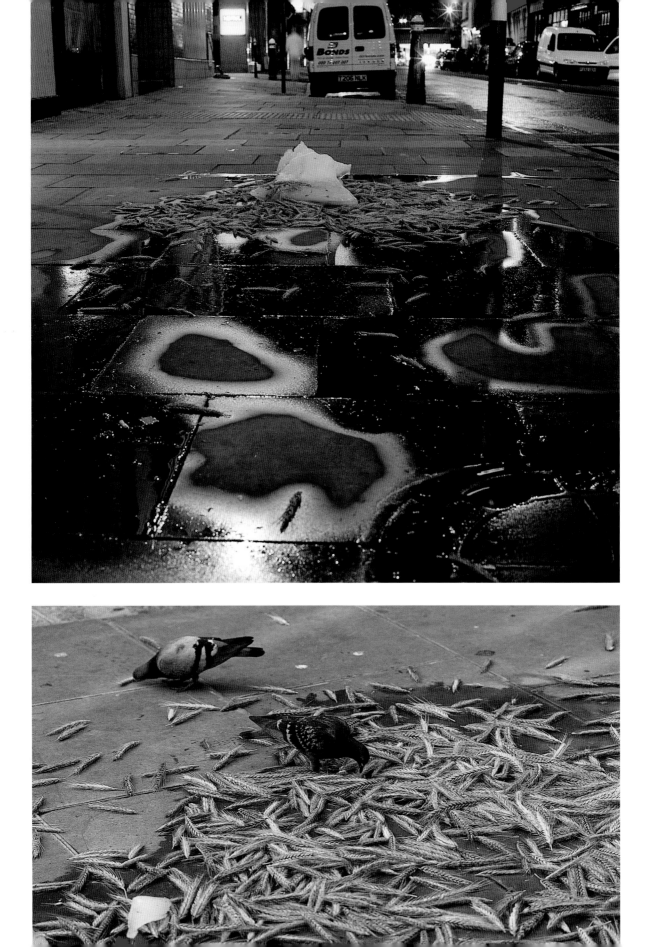

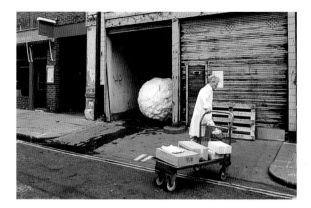

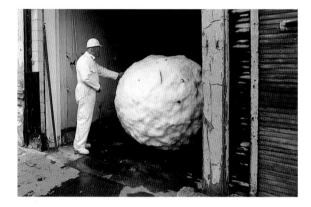

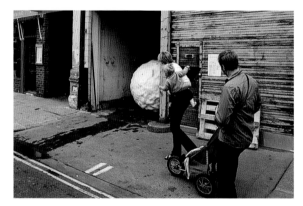

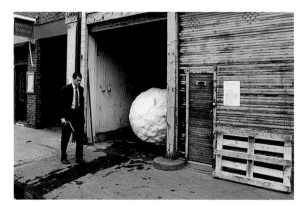

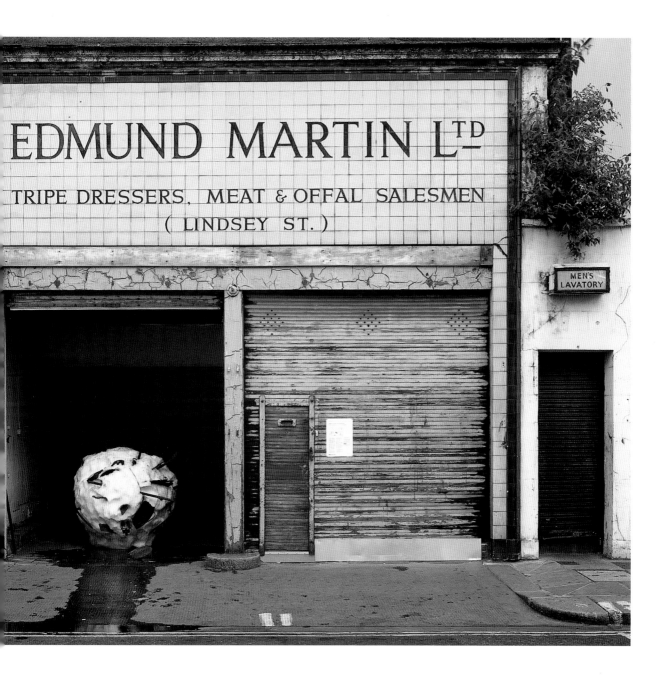

Metal

LINDSEY STREET

21 & 22 JUNE 2000

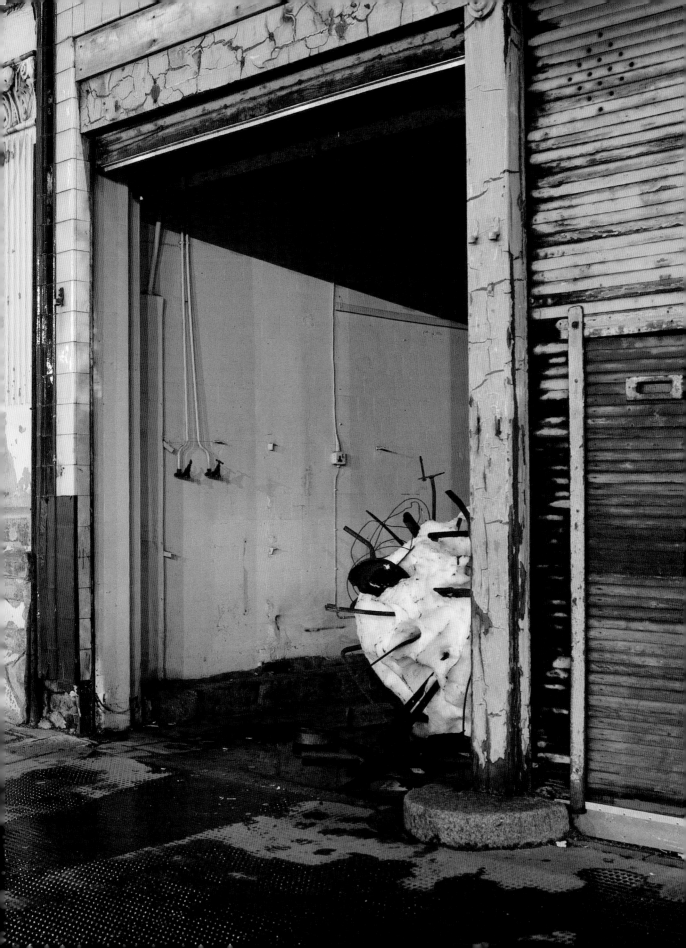

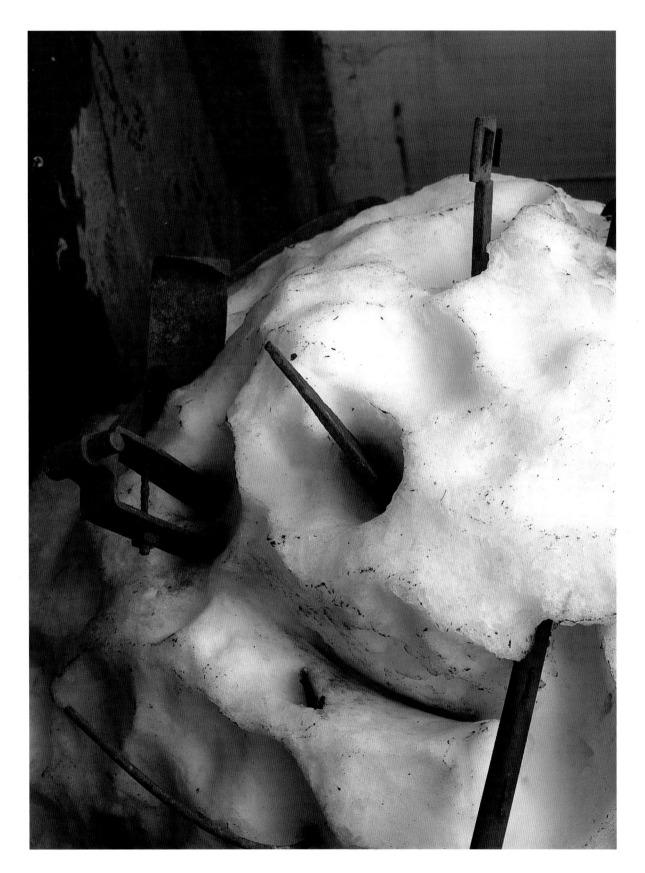

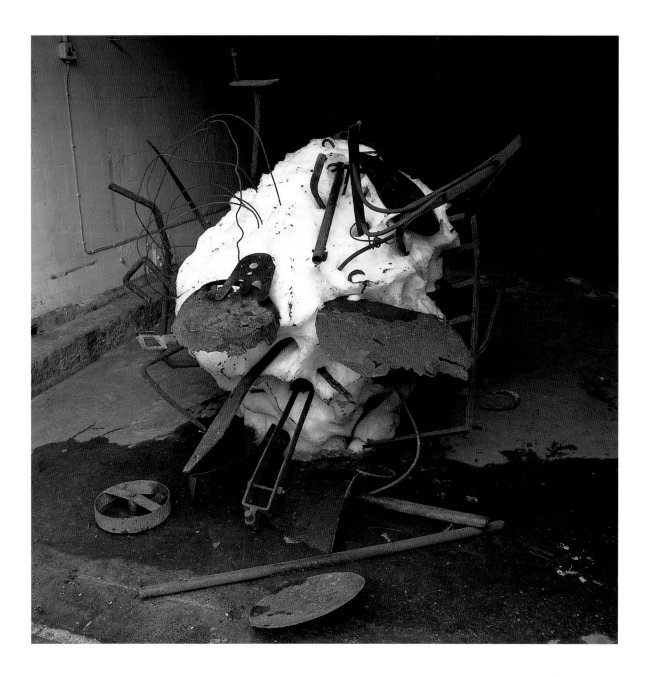

22 JUNE 2000

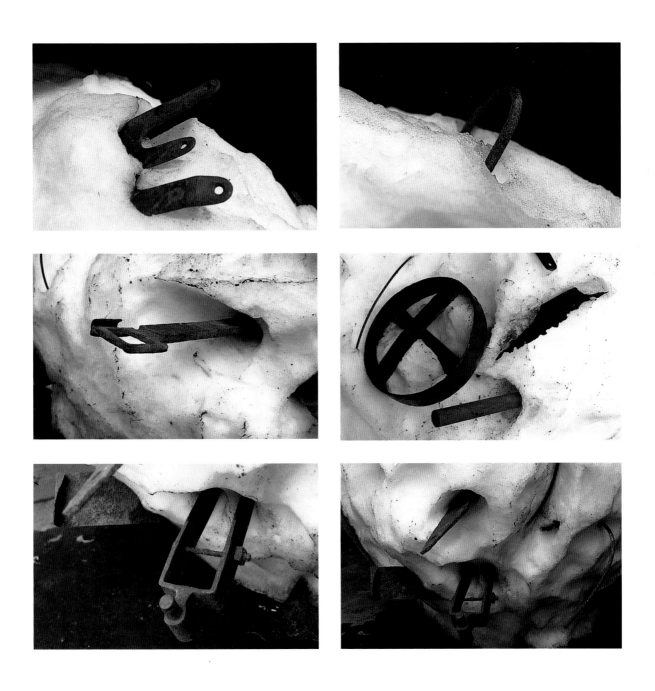

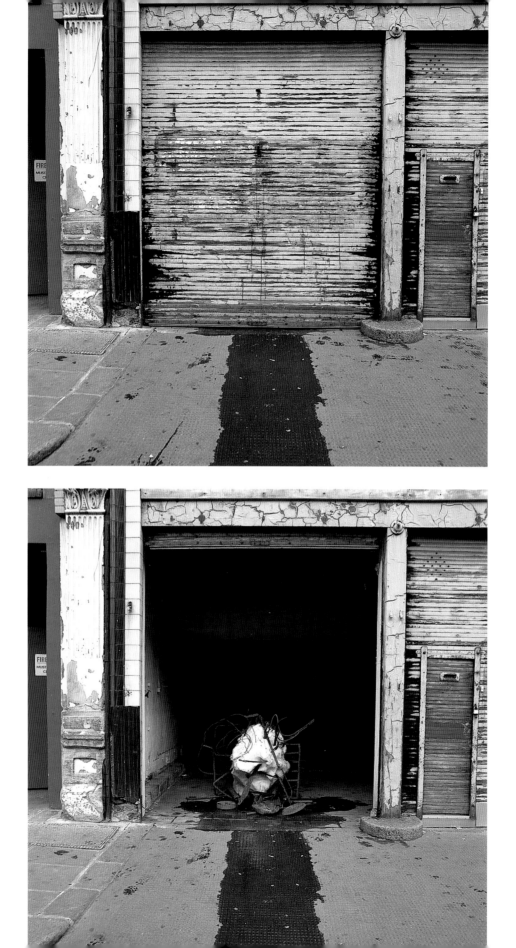

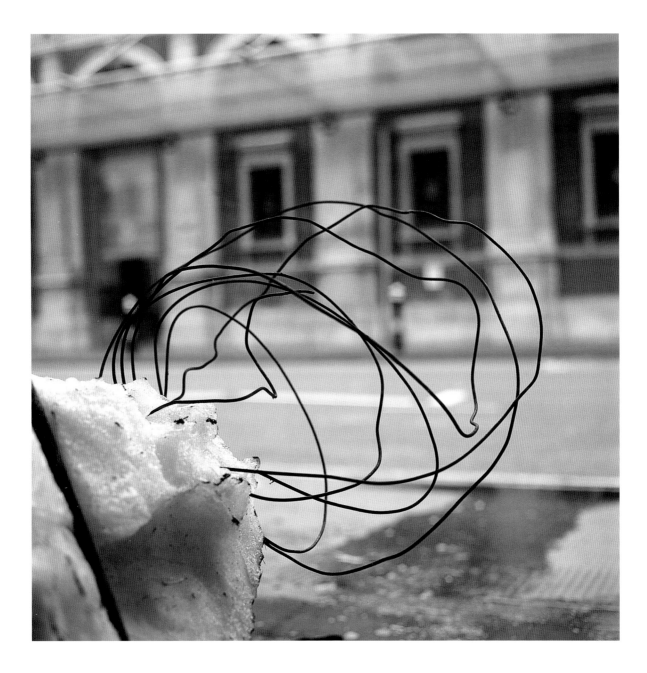

23 JUNE 2000

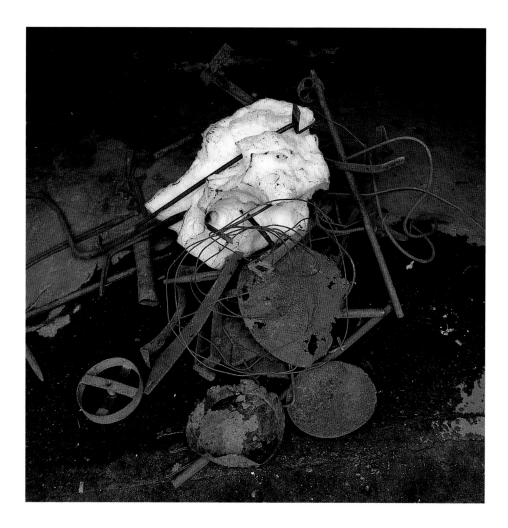

25 JUNE 2000

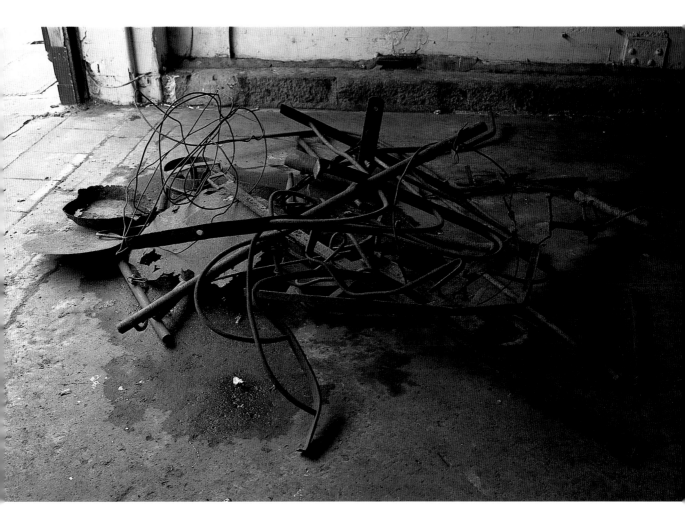

27 JUNE 2000

METAL

COW SHEEP CROW

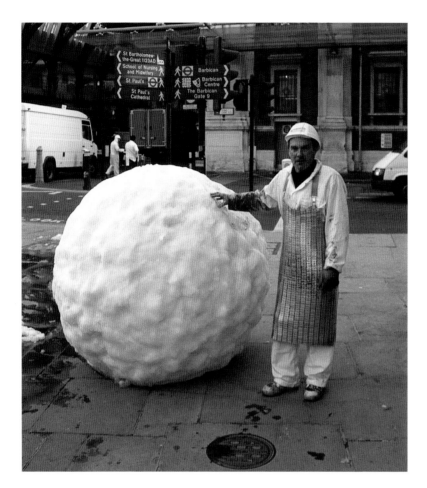

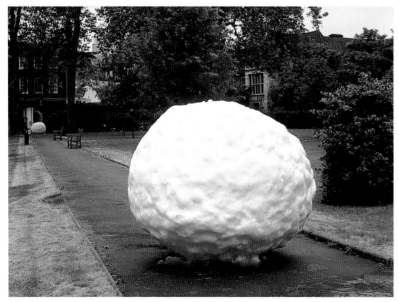

Cow hair snowball,
Long Lane & West Smithfield

Crow feather snowball (*left*) and
sheep's wool snowball (*right*),
Charterhouse Square

City of London, early morning,
21 June 2000

Wednesday 21 June 2000

The workers at Smithfield responded quite aggressively towards the snowballs. By about 8 am, one of them had been pushed into the gutter and two others had faces drawn upon them. A policeman made them put the cow hair snowball back onto the pavement, but before long it had disappeared again and I was told that it had been hidden in a freezer somewhere inside the market. This was much more interesting than the faces, which I disliked.

The snowball had in fact been put on the road at the other side of the market in a car parking area on the road. It was quite an interesting place, and, as journeys are part of the snowball project, I was not unhappy at its new site, although it had been slightly broken in the transportation.

Later on, I managed to talk to some the workers at Smithfield and explain the relationship between the contents of the snowballs and the market which seemed to generate more understanding and interest.

Thursday 22 June

The cow hair snowball has been moved yet again. This time – as it is still intact – I presume it was so that people could park where it had been put and that it was not interfered with maliciously or without care.

The sheep wool snowball ball is beautiful and is exactly what I wanted. There is little division between the snow and wool, which feels to have grown out of the snow, creating a white haze that moves and pulsates in the wind – as if the snowball were breathing.

The cow hair snowball has been moved yet again, to just off the road. My feeling is that these later movements have been responses to practical difficulties rather than mischief. It has proved very resilient.

A policeman was watching it, looking as though he was standing guard over it. There looks to be another day or so left in this snowball before it melts, but I fear that once it gets smaller, it will soon be stamped upon in the crush of market activity.

The wool snowball looked fantastic in the night light – glowing in the dark.

Friday 23 June

The wool and crow snowballs are still there and look as if they will survive at least another day. The feathers on the floor have given one of the strongest debris patterns. As somebody said, it is the wool, rather than the feathers, that seems to have wings. The feathers are stuck, plastered to the pavement, earthbound in a way that the wool, which is blowing around in the wind, is not.

Tonight will perhaps be a test for the cow hair snowball. There is no market and it will be left to fend for itself during the testing time when people leave the nearby clubs and pubs.

Saturday 24 June

Went first to the cow hair ball, which had survived the night and looked to have another two days melting left in it, but by late afternoon it had gone. The smaller the snowball has become, the more vulnerable it is to being swept away by street cleaners. When I came back to see it, there was no snow and very few bits of hair. I scraped up what was left and rolled it into a small hairball, the nucleus of the snowball.

This snowball, which began its melt under great threat, has lasted longer than any of the others in unprotected sites. This can only have happened because of the goodwill of the market workers and although they would never admit to enjoying its presence, the fact that it survived so long suggests that they did. Or possibly they just tolerated it, which is enough.

The crow feathers snowball is almost at its end. The emergence of the feathers has been disappointing. The wind has prevented any build-up of feathers on top of the snowball which I had hoped would turn it black. Instead it looked like Desperate Dan's chin.

The site has offered the snowball some protection and, even though a local school uses the park at break times, most of the feathers are still on the ground. I like the structure that the rhythm of the melt has imparted to the debris. The white quills give a dynamic quality to the random pattern that has formed. It is something that I may explore in future work.

The wool snowball probably has another day left. The snow continues to melt into wool, which is then blown around the site.

Cow hair

LONG LANE &

WEST SMITHFIELD

Morning

21 JUNE 2000

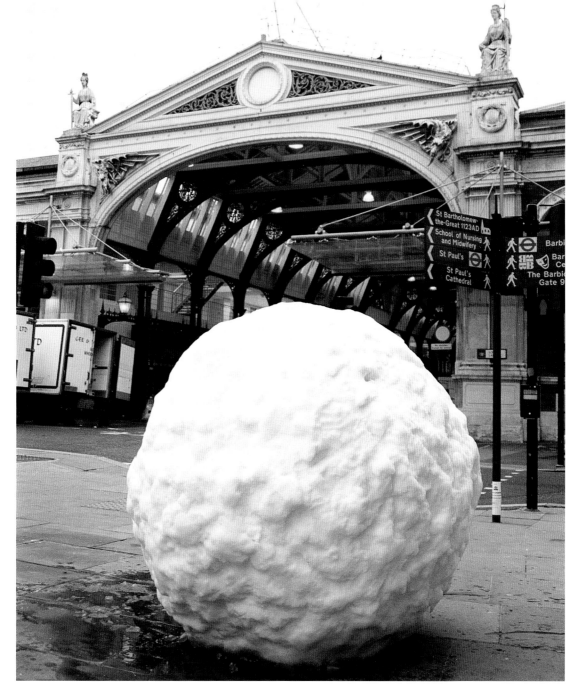

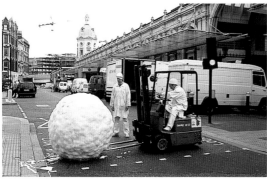

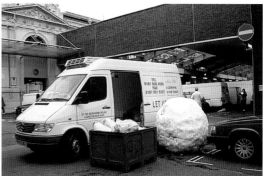

COW

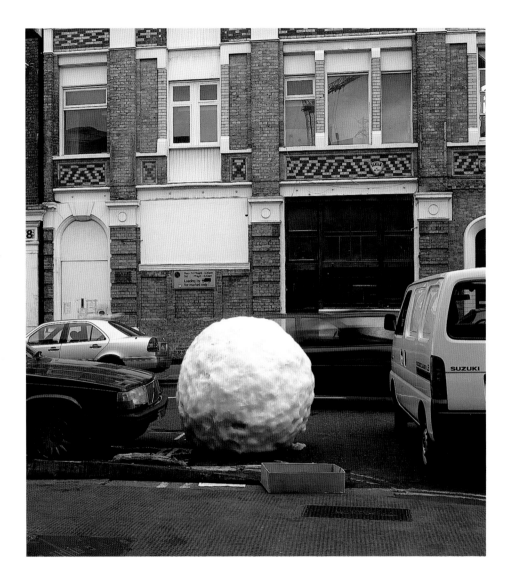

Morning and night

21 JUNE 2000

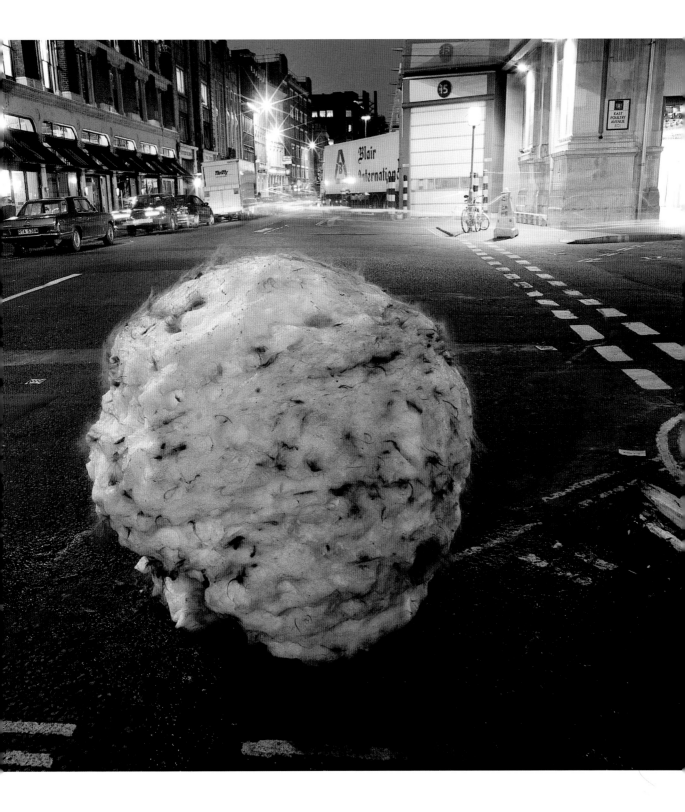

COW

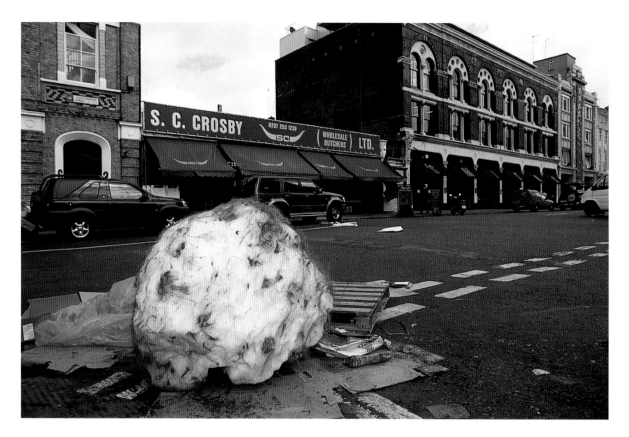

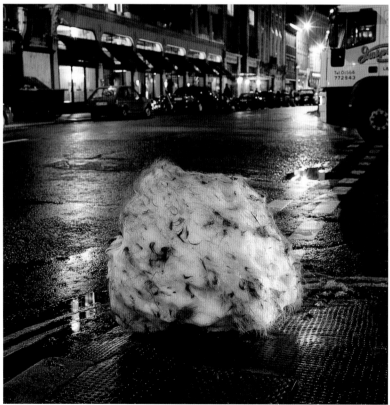

Morning and night

22 JUNE 2000

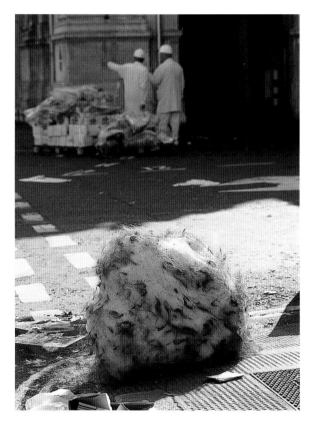

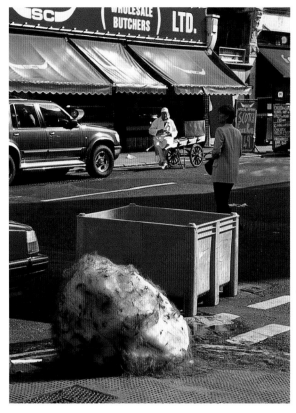

Morning

23 JUNE 2000

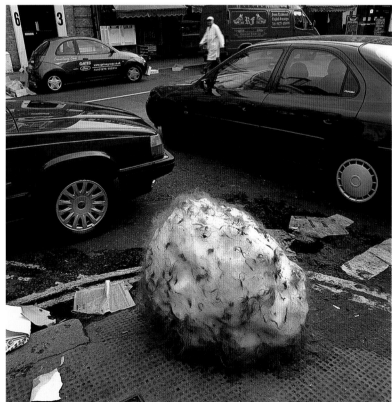

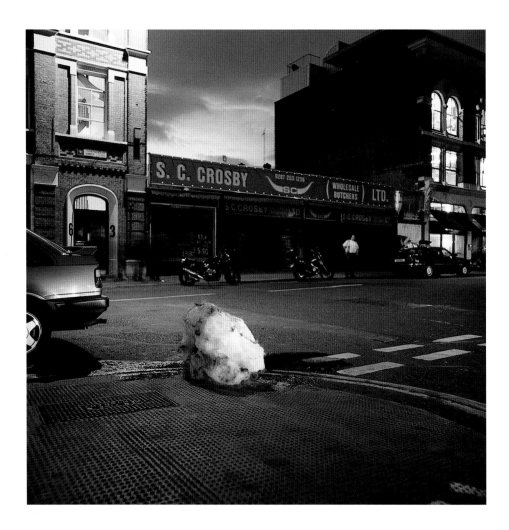

Night

23 JUNE 2000

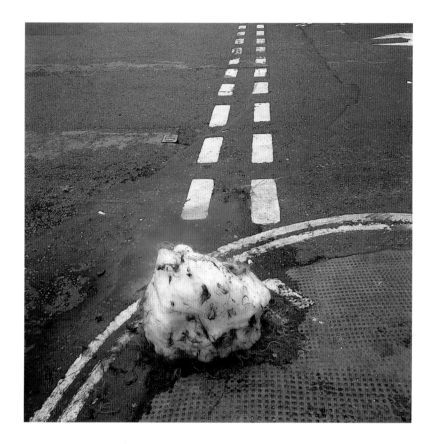

Morning

24 JUNE 2000

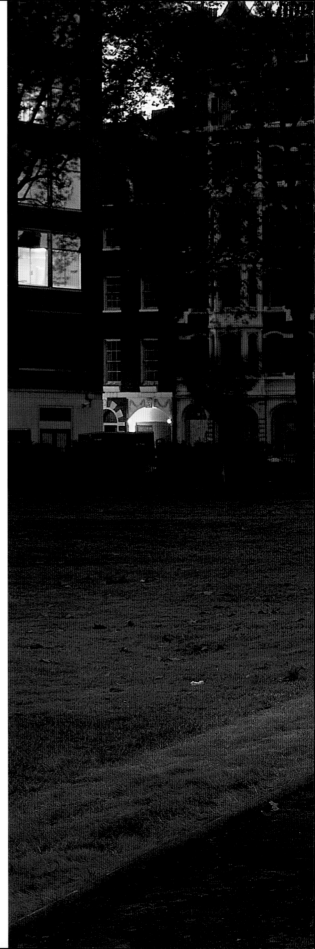

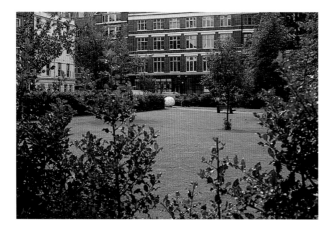

Sheep's wool

CHARTERHOUSE SQUARE

Mornings

21 & 22 JUNE 2000

SHEEP

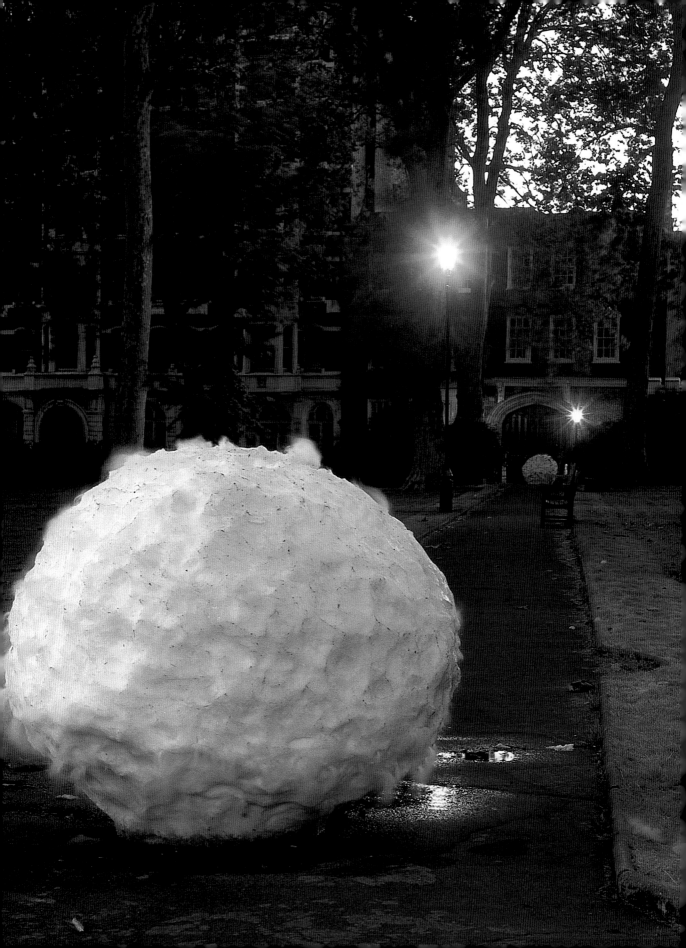

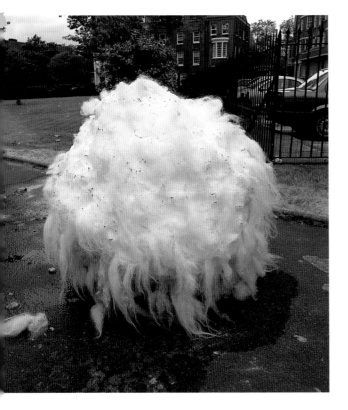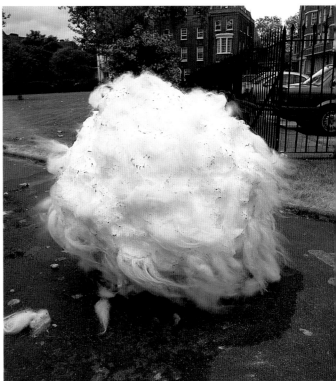

22 JUNE 2000

SHEEP

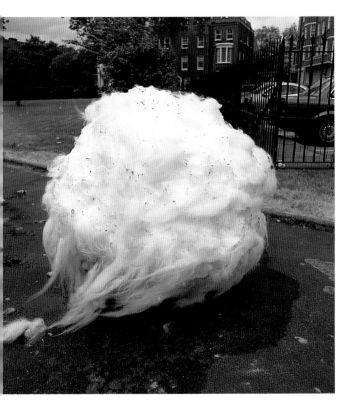
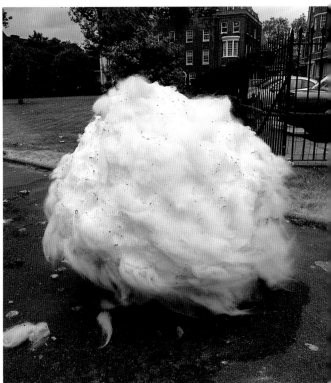

SHEEP

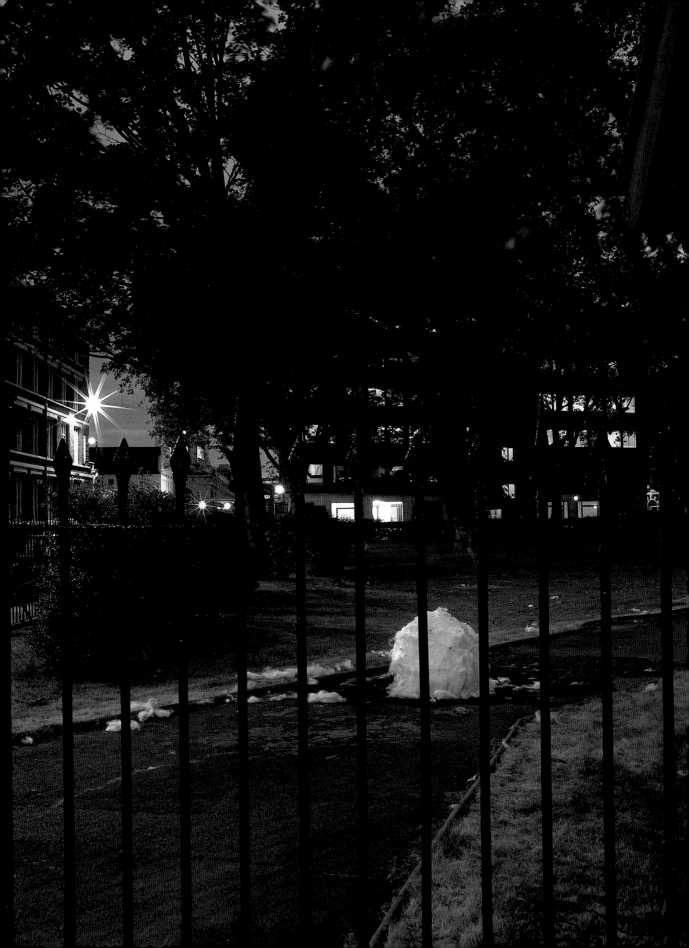

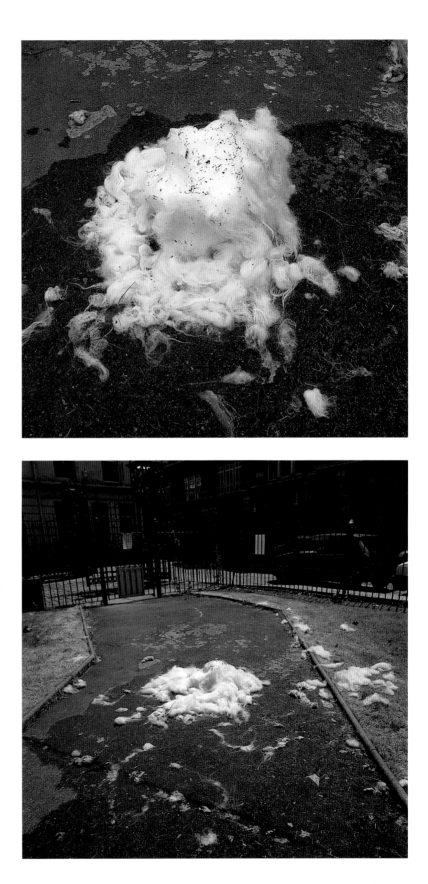

This page

Morning

25 JUNE 2000

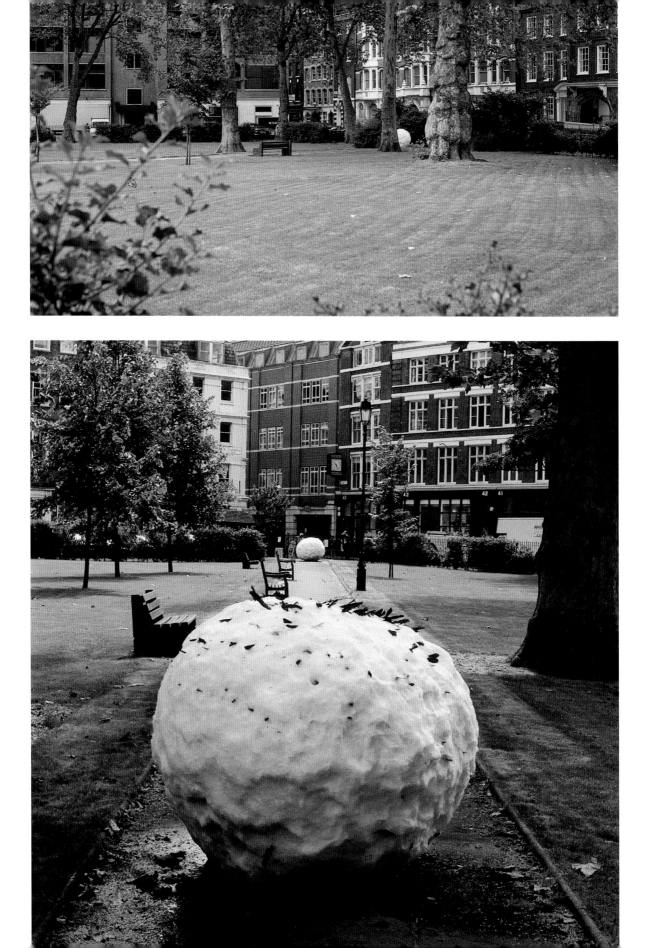

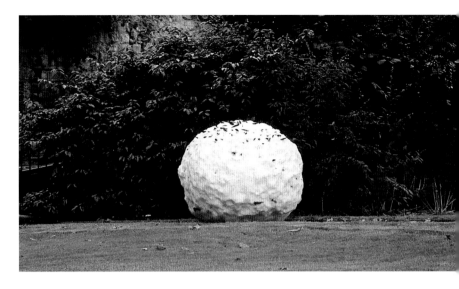

Crow feathers

CHARTERHOUSE SQUARE

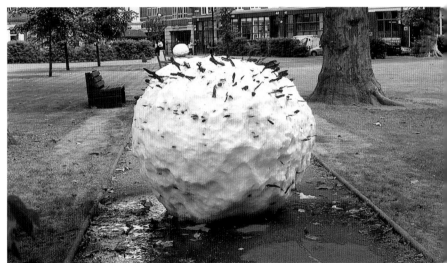

Morning to late afternoon

21 JUNE 2000

Overleaf

22 & 23 JUNE 2000

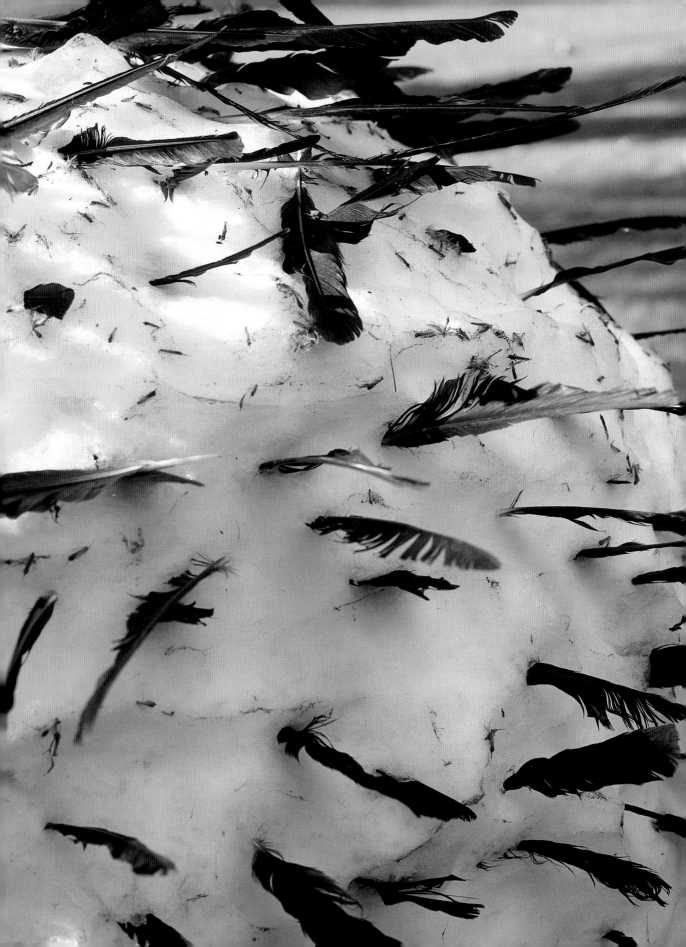

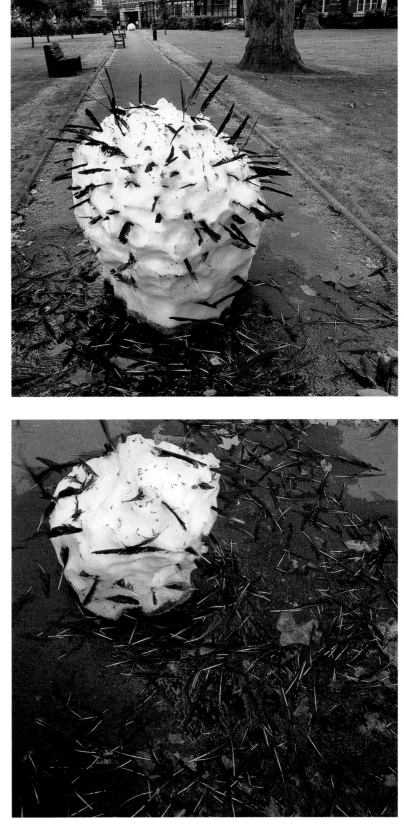

CROW

PEBBLES CHALK

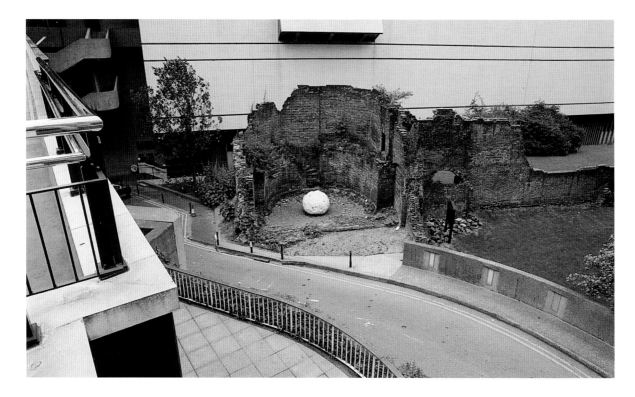

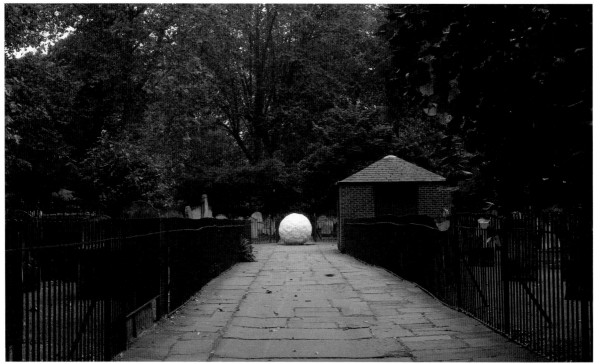

Wednesday 21 June 2000

There were so many different reactions to the snowballs. Many people needed to touch before they accepted that they were made of snow. The one in Bunhill Fields worked well in this respect: approached by a long path, it was first seen from a distance. One person told me that he thought it was snow but didn't believe it. The closer he got, the more he tried to convince himself that it wasn't snow until finally he touched it. Touch is a confirmation – a test of what and how we see.

Thursday 22 June

I went to the chalk snowball at Bunhill Fields just after the cemetery was opened, and there was good debris on the floor. This snowball is sheltered and is taking longer to melt than some of the others. There are a few days left in it.

Later, after dark, I went round the sites again. Bunhill Fields cemetery was closed, but I have a key that allows me access. It is very peaceful, quiet and protected, a sanctuary compared to the streets. It had been raining and the snowball was reflected in the wet pavement. It is beginning to thaw at the sides making the form elongated and upright, which creates a dialogue with the monuments that are around it.

Pebbles snowball,
Bastion,
Old London Wall

Chalk snowball,
Bunhill Fields

City of London,
morning, 21 June 2000

Friday 23 June

The pebbles snowball was completely melted apart from one small piece of grey snow that almost looked like a pebble itself at the centre of where the snowball stood. There was a hole in the middle of the debris which echoed the base of the snowball. This snowball suffered most from having its contents removed. I missed the heap of pebbles that would have accumulated upon and around it.

The chalk snowball is gradually eroding. I keep seeing the same people over and over again. Many go around looking at the snowballs before and after work. It is difficult to describe people's reactions and the looks on their faces. I had set up my camera to photograph the chalk snowball in the strong sunlight when a woman came up to the snowball and touched it. This image will be a better description.

Saturday 24 June

Last night the chalk snowball in the cemetery was decapitated, which was a shame. It was taking on a similar quality to the chalk snowball in Glasgow: it became a slim column which looked so well constructed that some people thought I had carved it. When I returned this evening, the remaining small bit of snow had been lifted up and thrown up against nearby railings into which it had begun to melt.

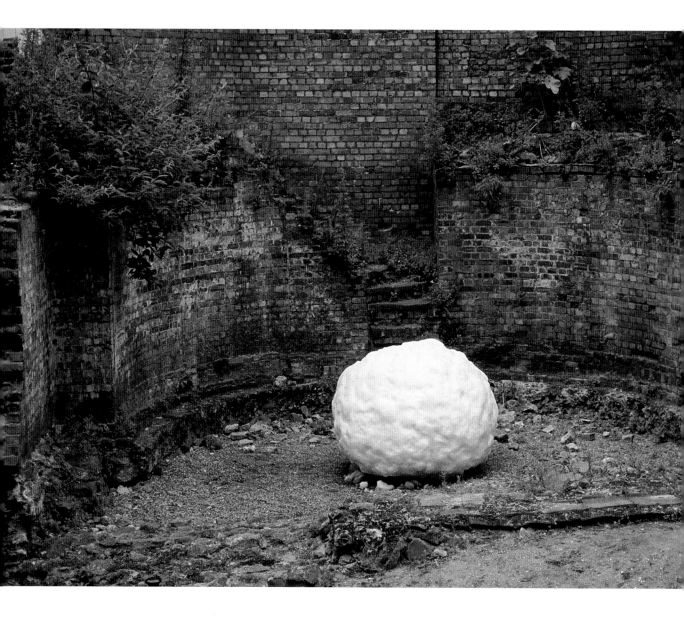

Pebbles

BASTION, LONDON WALL

Morning and afternoon

21 JUNE 2000

PEBBLES

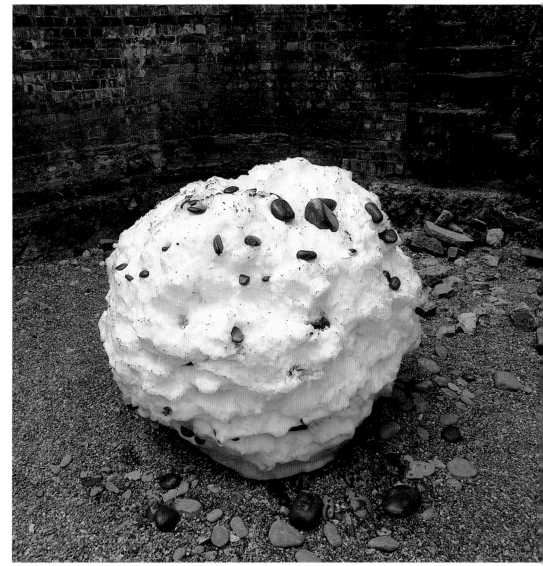

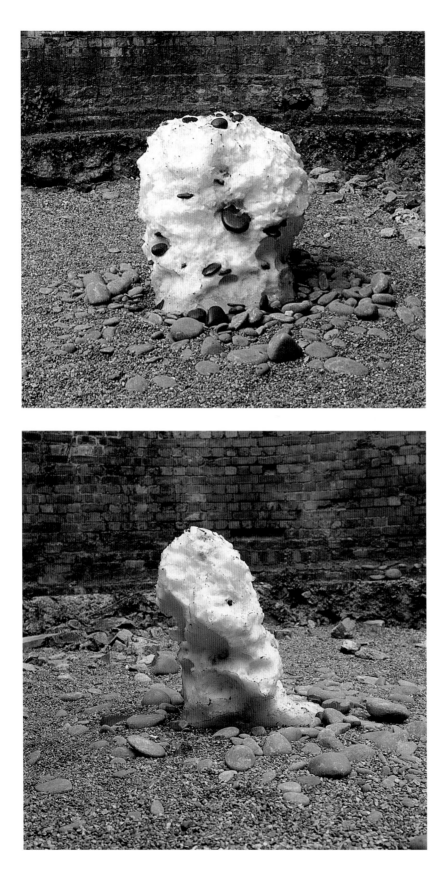

Morning to morning

22 & 23 JUNE 2000

PEBBLES

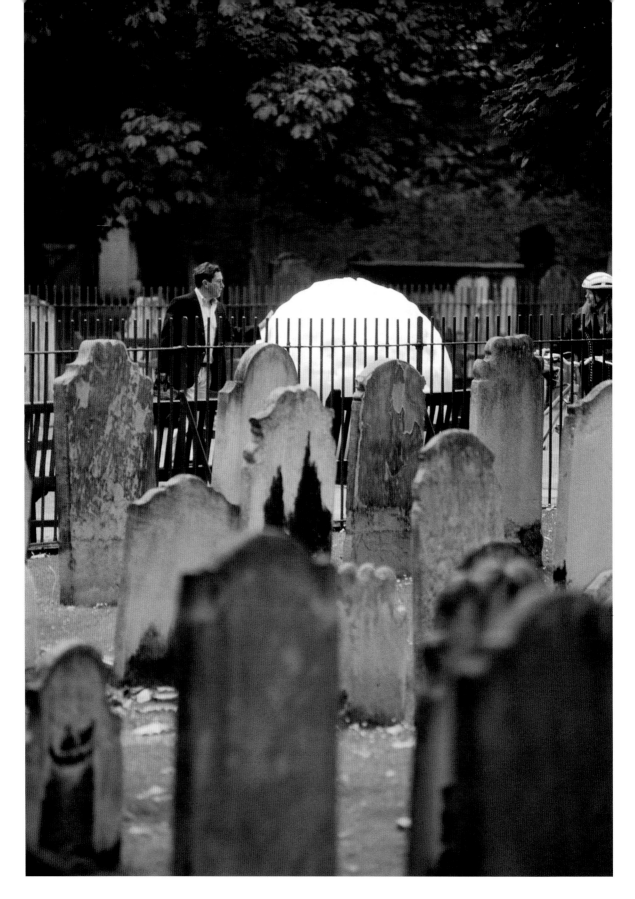

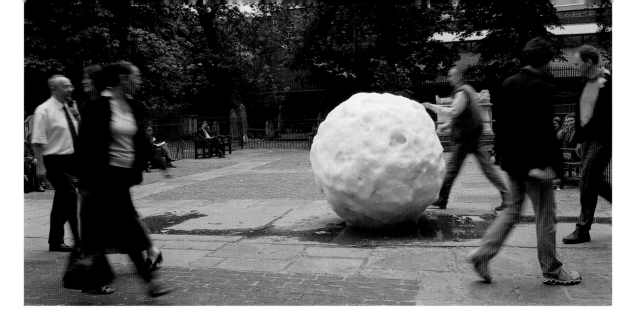

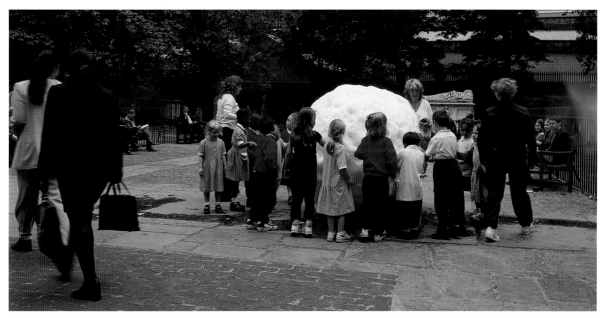

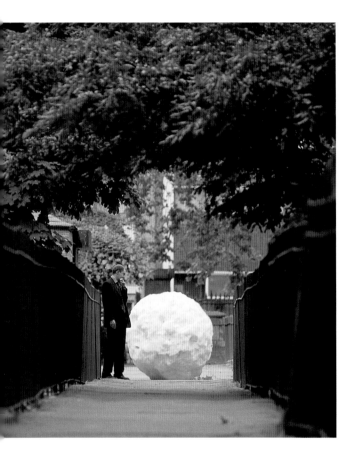

Chalk

BUNHILL FIELDS

Morning (*previous double page*),
morning and afternoon (*above and right*)

21 JUNE 2000

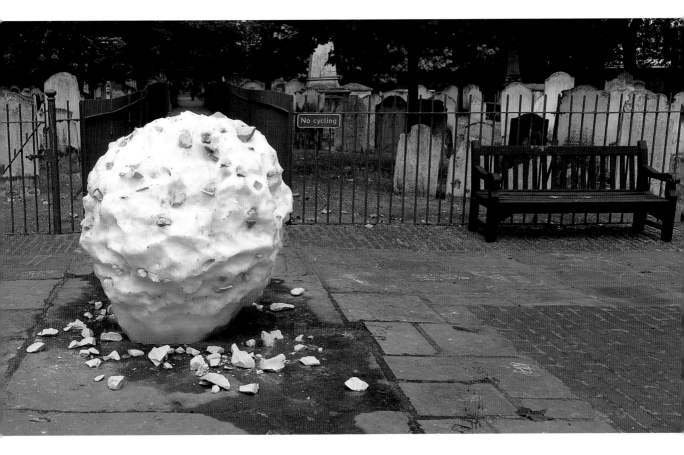

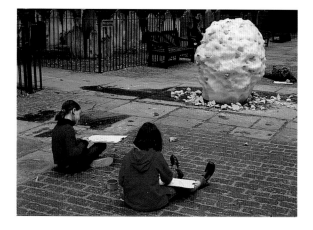

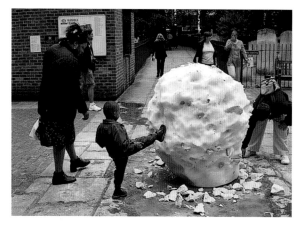

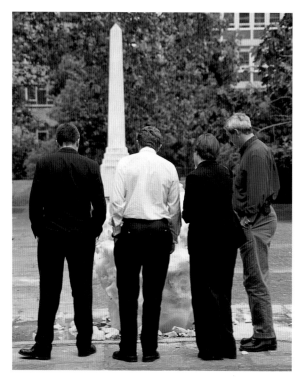

Morning to dusk

22 JUNE 2000

CHALK

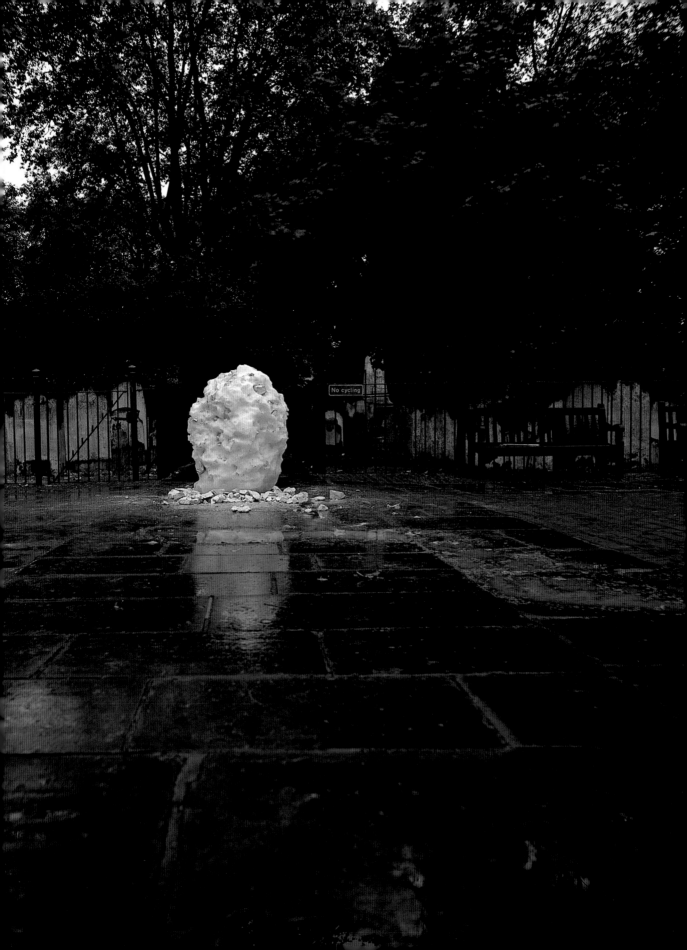

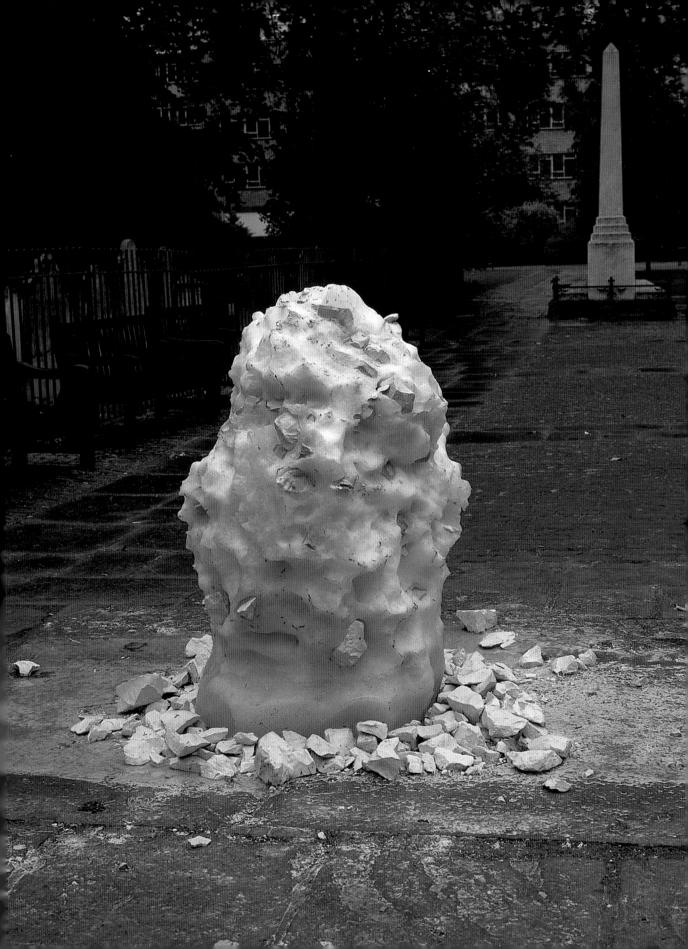

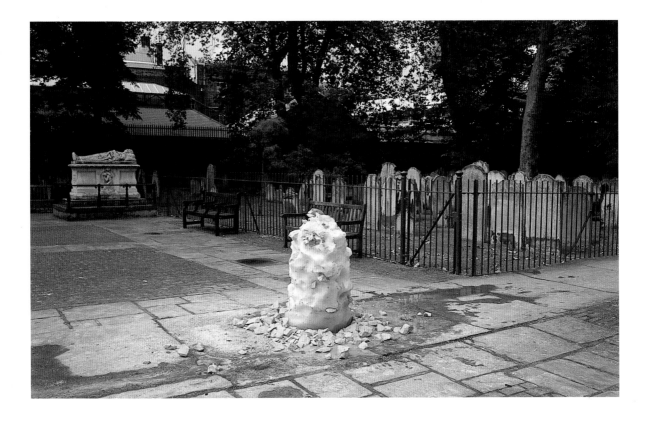

Dawn
to late afternoon
23 JUNE 2000

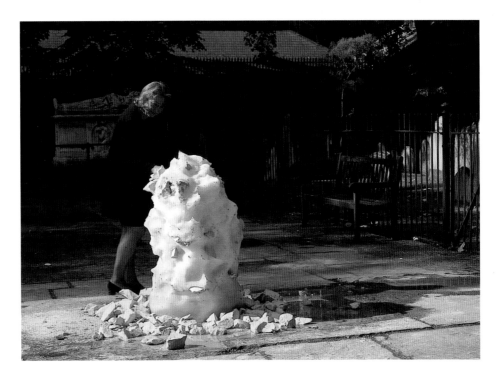

CHALK

Dawn

24 JUNE 2000

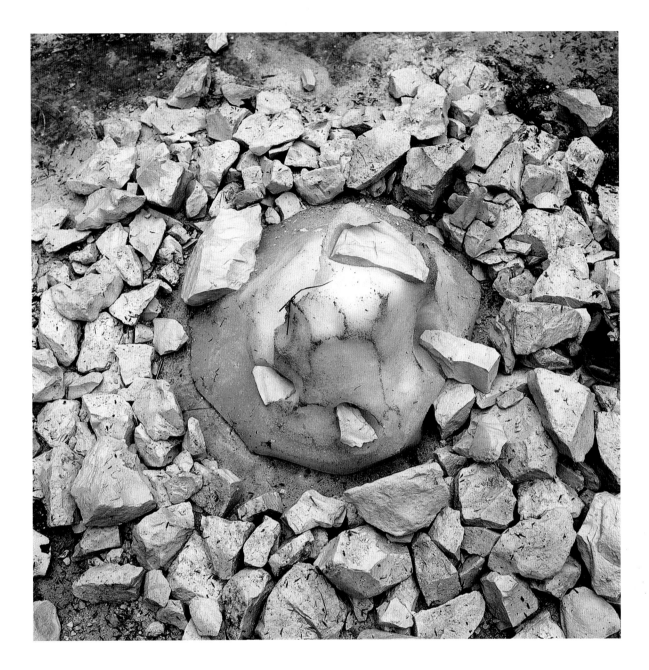

Afternoon

24 JUNE 2000

CHALK

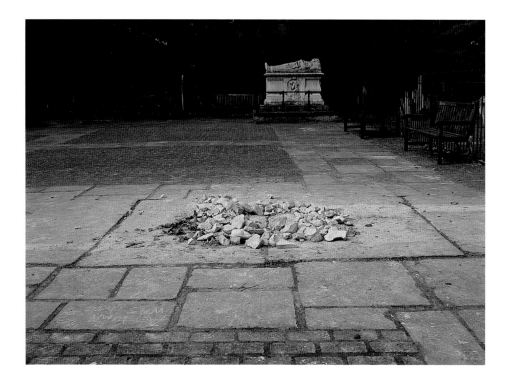

SCOTS PINE, ASH, HORSE CHESTNUT – destroyed at around 4 am on Thursday 22 June

ELDER – swept into gutter by midday on 22 June

BRANCHES – melted by early evening on 22 June

PEBBLES – melted by around midday on Friday 23 June

BARLEY – swept away around midday on 23 June

BARBED WIRE – finished melting on the morning of 23 June

COW HAIR – went during the afternoon of Saturday 24 June

CROW FEATHERS – melted by late evening on 24 June

CHALK – last snow removed during evening of 24 June

WOOL – lasted into the morning of Sunday 25 June

METAL – lasted into the morning of Monday 26 June

RED STONE

Saturday 25 August

The last of the fourteen snowballs was installed yesterday in the Curve gallery at the Barbican. I had intended that it would melt at the opening of the exhibition, but concerns over a wet floor and public safety meant that this could not happen. For the snowball to melt publicly at this time would have meant either placing it in some kind of tray that would collect the water or sitting it outside.

Neither of these options interested me. Placing the snowball outside would have been a repetition without a purpose, and a tray would have restricted the flow of water and framed the resulting stain – separating it from the building with which it was intended to engage.

Instead, I decided to melt the snowball in advance of the opening so that people would be presented with its shadow – a stain on the floor – evidence of its presence.

In some ways this made the idea stronger. I was reminded of the sand work in the Egyptian Sculpture Collection of the British Museum in 1994, which had to be made, photographed and removed before the exhibition opened. It was feared that such a large work would constrict people's movement through the gallery. The sculpture was represented as an image and appeared on the poster that announced the exhibition. Although it was intended to make people think of its presence by its absence, it also left tangible signs of having been there by a slight staining on the floor which was still evident a few years later – if you knew where to look.

Even though the snowballs on the streets have gone, the memories of them are embedded in the places where they melted.

Getting the snowball into the gallery proved difficult. I knew that it would be too big to get through the door and was prepared to shave something off the sides in order for it to pass by, but was suprised when a good foot had to be removed. Once it was in the gallery I stuck the snow back on to the ball.

It was soon evident that the snowball was going to produce far more water than I had anticipated and it was not long before I began mopping up the excess. The room next door and the one below contain electrical equipment so it was important that the water did not become too deep at the room edge.

My big concern was that the snowball was producing clear, unstained water. But towards the end of the day the red began to flow.

In the evening I watched a performance at the Barbican Theatre and when I returned to the gallery afterwards I found that the water had spread over a very large area. My heart sank. I felt tired after the installation, my head ached and now I would have to sit with the snowball through the night. I cleared away more water and went back to my hotel to sleep for a couple of hours.

During the night the flow of red became stronger and, despite lack of sleep, the strengthening colour gave me new energy. Even though my role in this work is now a passive one it is important for me to witness its making and be its guardian.

I should possibly have first done a trial, away from the pressure of an exhibition. But I like the intensity that accompanies risk. The older I become, the more uncertain I am able to be about the outcome of an installation. This gallery has become more like a studio than an exhibition space.

Sunday 26 August

Today the colour became richer and spread further away from the snowball, which is about half the size it was yesterday. There will soon (I hope) come a point when the snowball cannot sustain the area over which it has spread and will retreat allowing the floor that it has stained to dry out. Until then, the snowball has to be watched, and tonight I have to stay with it once more.

All this time the clay wall has been cracking. Concealed behind the wall are vents through which air has circulated during its construction, and this has caused parts of the wall to crack prematurely, revealing fissures that are too big for comfort. The ventilation system has now been switched off.

Whilst the clay wall needs to dry slowly, the snowball would benefit from some movement of air to help the water to evaporate and at the same time allow the pigment to concentrate. Lifting the water also removes colour, which is unfortunate. Evaporation creates forms and variations in the drying that do not occur if water is taken too quickly. Different densities of pigment become separated in water which are then deposited as the water recedes, leaving waterlines on the paper.

There are interesting connections between the wall and snowball. Both works make use of surface tension – the wall more successfully, as I am forced to break the surface of the snowball each time I remove water.

It rained today, leaving puddles on the pavement and roads. I took some of the red from the snowball and stained three pools: one on the pavement and two on the road. The colour looked quite violent on the black tarmac – more like blood than stone, a connection that I like.

I also like the idea of linking the indoor melt and eventual disappearance of the snowball to the steets and pavements of the city outside.

Monday 27 August

I spent most of the night in the gallery. The water is pouring out all over the floor. The stain has spread to all parts of the pool, making it difficult to remove water without dramatically affecting the drawing. In some ways it is right that my touch affects its appearance and my presence has in some way left an imprint on the drawing.

I have taken most of the water from the edge of the pool, where it was still clear. But I could only take a small amount of water at a time – by contrast with last night when I was able to mop up the water in quantity. Consequently I was up most of the night, sleeping occasionally on the seats in the foyer. The fire alarm went off at one point and I had to leave the building whilst firemen checked out the problem which turned out to be fumes in a lift shaft.

The work is proving to be far more demanding than I had anticipated, though not uninteresting. The process of watching something being born and grow has a tired, tense, slow excitment driven more by a fear of what may happen if I am not there than by what occurs whilst I am in the gallery. I am bored when there but feel an urge to return the moment I leave, having learnt that problems occur when I am away.

By the evening the remaining snow was much reduced and I felt that my vigil was drawing to an end. The amount of water coming out seemed now to be only a trickle, and fans that had been placed nearby appeared to be drying up any accumulating water. That was the intention anyway. I went to see *Time Code,* a film showing at the Barbican, and when I came out the pool had extended even more. To my disappointment, it had covered almost two islands of dry floor that I had been hoping to keep.

It also meant another night at the gallery.

Tuesday 28 August

During the night, the melt slowed down. The work reached a point similar to the turning of a tide and the water began to receed. I was able to go back to my hotel at about 3 am. When I returned to the gallery later that morning the snowball had gone.

Watching this snowball melt in the protected space of the gallery has been an interesting conclusion to the whole project. Outside the snowballs seemed so vulnerable. Indoors the situation has been reversed – it is the building rather than the snowball that has been more threatened. The reason for me watching over the work has been to protect the building not the snowball.

It has been good to see one snowball melt to its full potential, watching debris accumulate cairn-like on its top and to see it become slender and tall before collapsing. When I left the Barbican this evening it was raining. As I walked down Silk Street I noticed a long flow of water running for quite a distance in the middle of the pavement – what a great place that would have been for the snowball! I could visualise the blood-red stream of water flowing out – people seeing first this red trail then following it to the snowball, touching it just as all the other snowballs were touched but in this case coming away with red stained fingers . . . all those children covered in red.

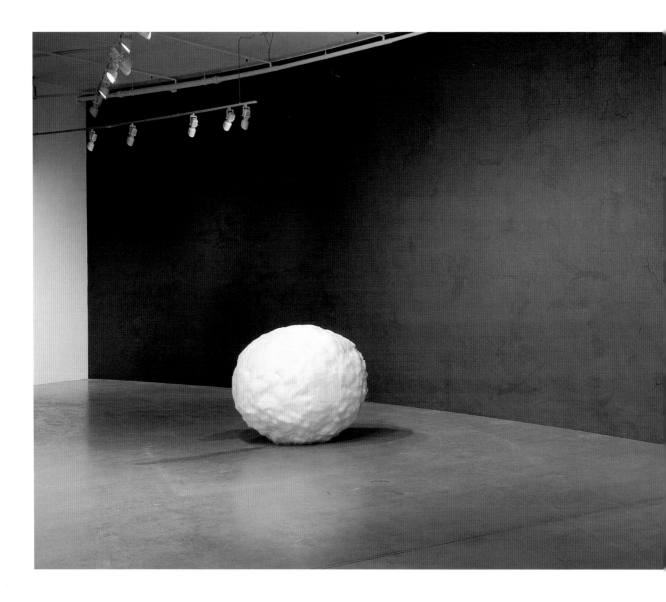

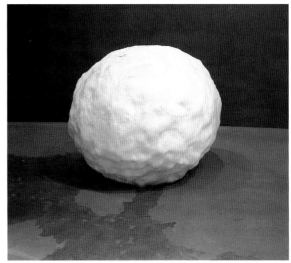

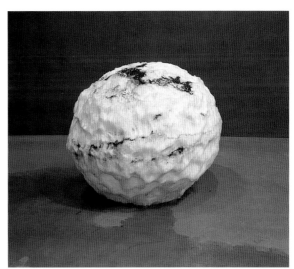

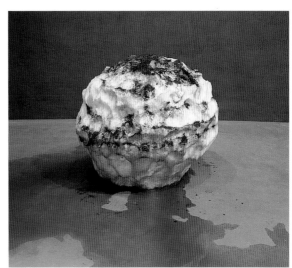

RED STONE

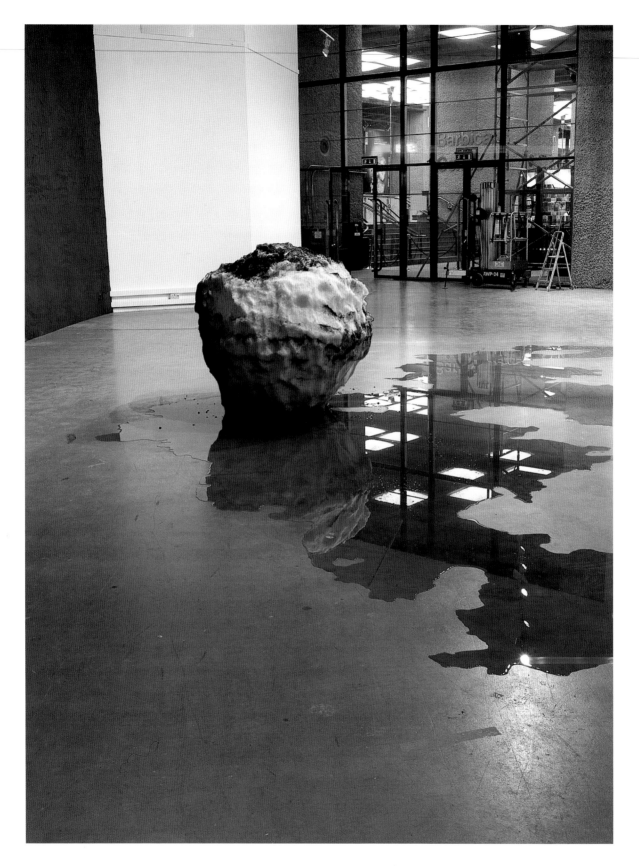

RED STONE

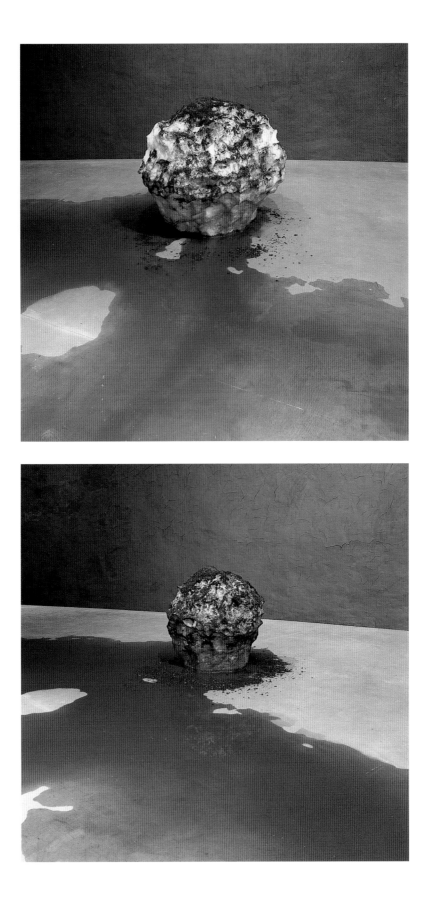

RED STONE

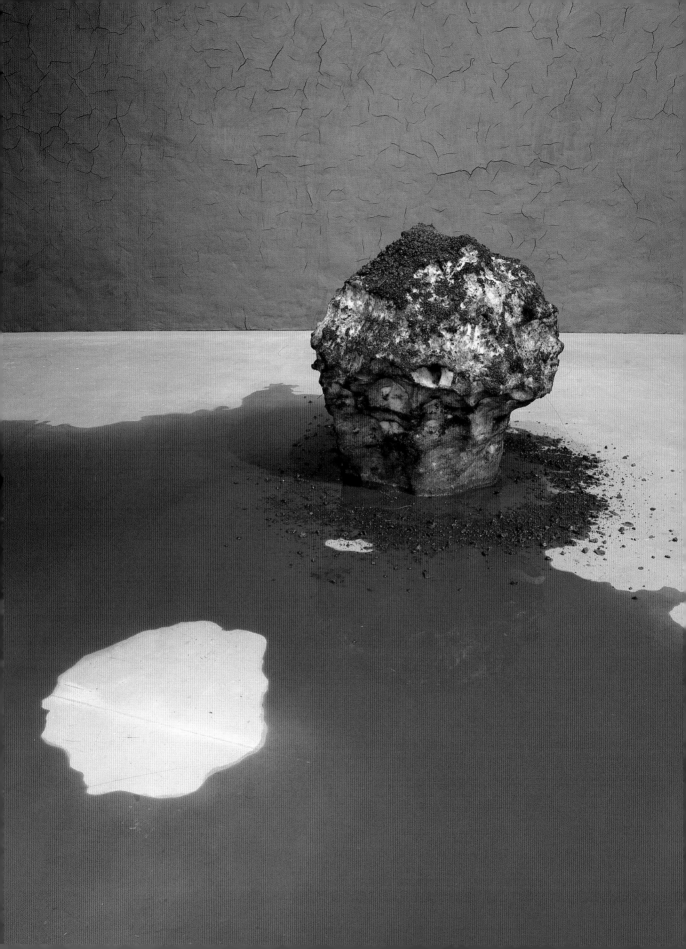

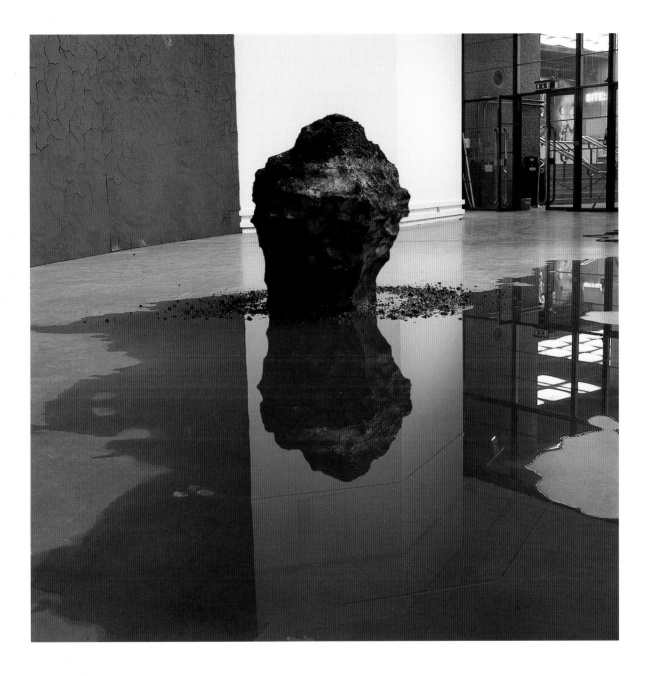

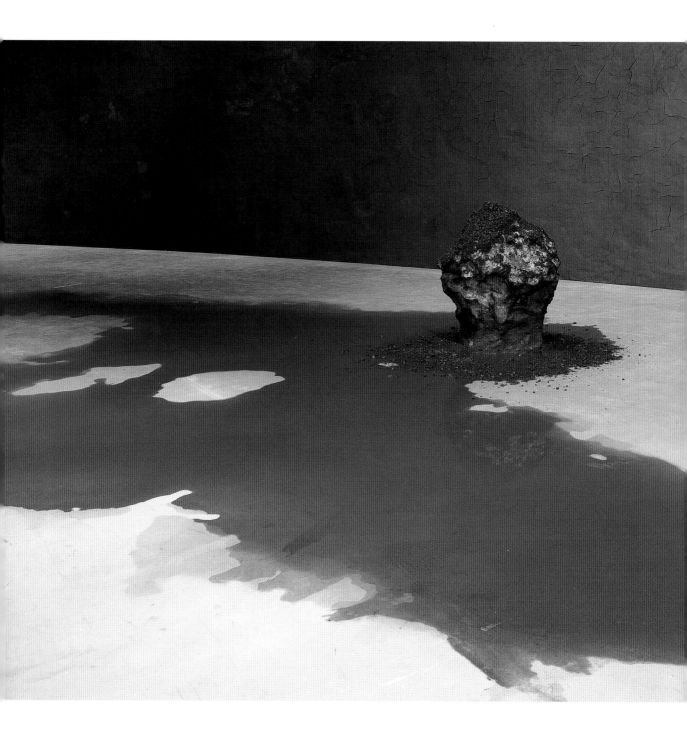

RED STONE

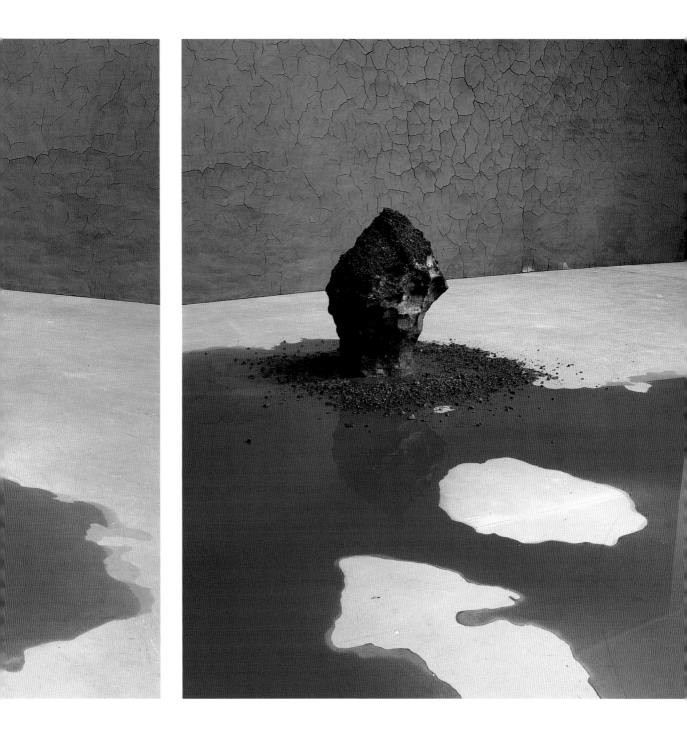

RED STONE

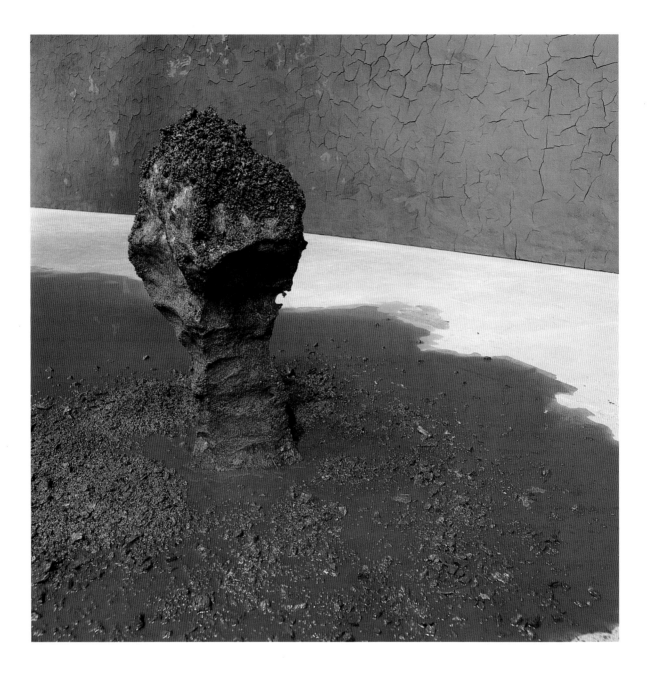

RED STONE

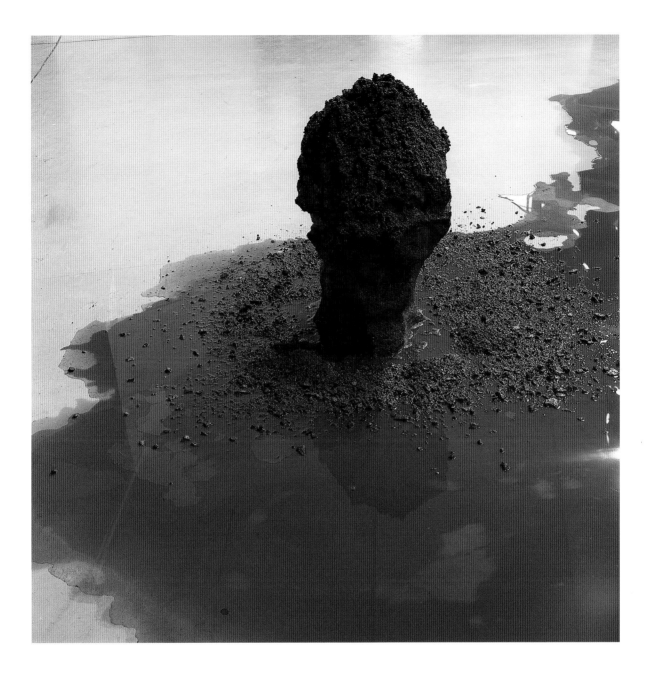

RED STONE

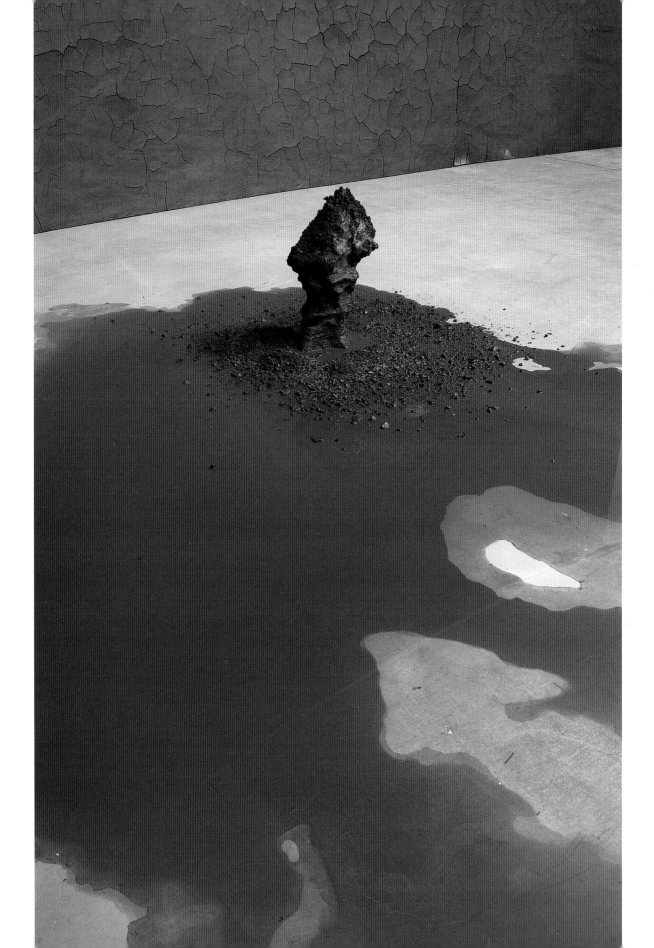

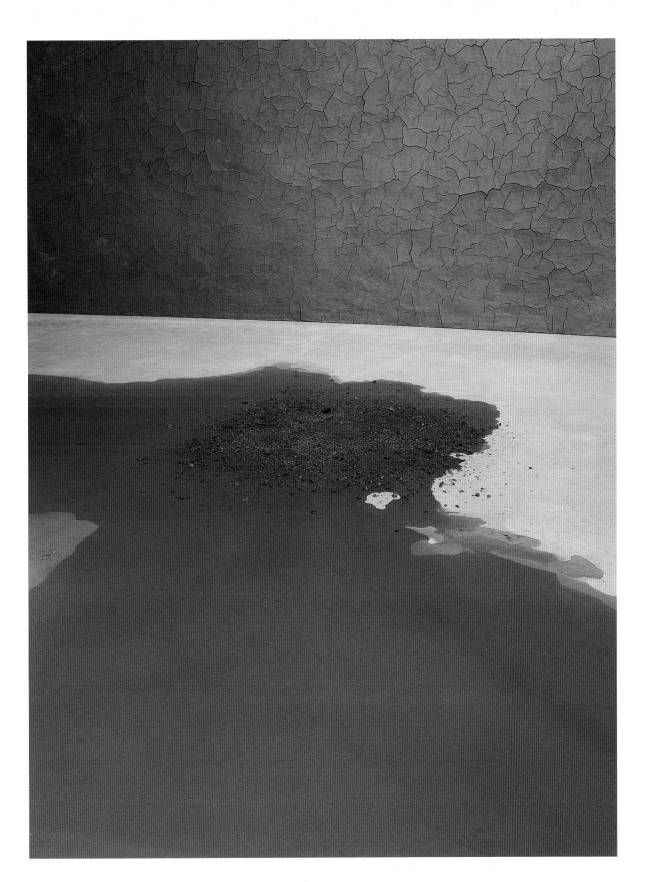

RED STONE

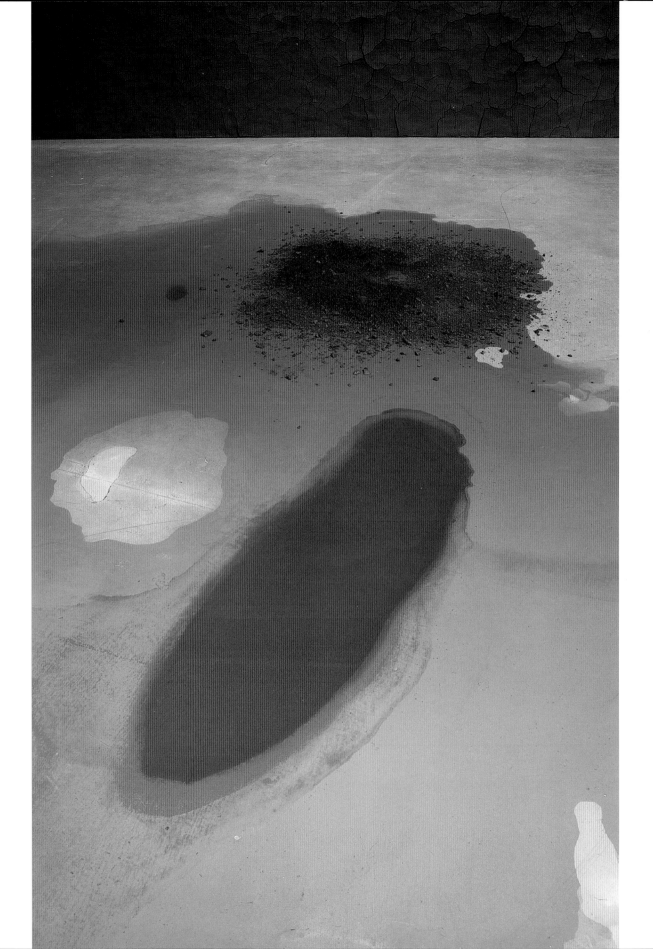

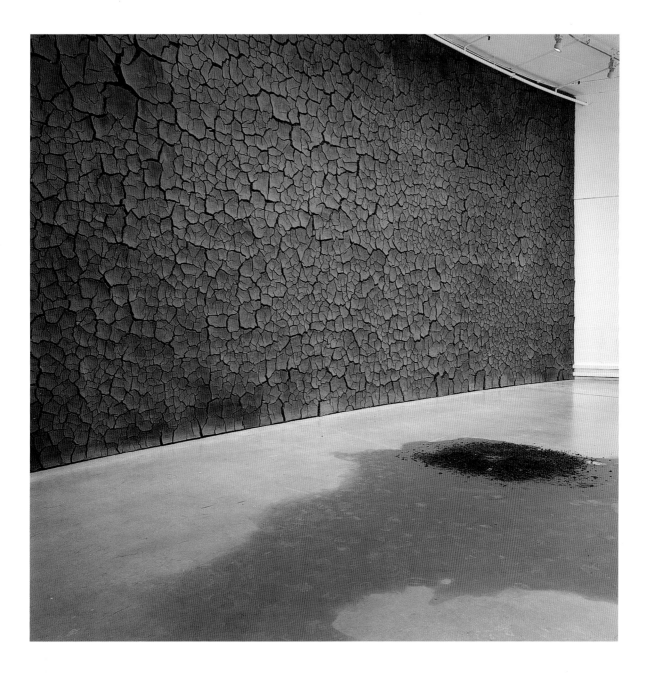

RED STONE

ACKNOWLEDGEMENTS

My first thanks are due to the Barbican Art Centre which took on the considerable task of organising this ambitious installation, and to Christian Salvesen, whose generosity extended from storing fourteen snowballs of considerable dimensions in their cold store facility in Dundee (some for as much as eighteen months) to transporting them all down to London. From the Barbican, I am particularly grateful to Conrad Bodman (Curator), Carol Brown (Head of Exhibitions), John Hoole (Art Galleries Director), Peter Sutton (Production Manager), Patrick Cameron (Exhibition Organiser), Lisa Collins, Alison Green and Fiona Lowry, who were extremely supportive. At Christian Salvesen, I was given friendly and generous help by David Cornwall, Colin Craig, Jim Davidson and John Davidson at the Dundee depot and Frances Gibson-Smith in the Northampton office and Paul Pegg from Peterborough.

But Midsummer Snowballs would not have been possible without the assistance of very many other people, and the following individuals and organisations deserve a special mention:

for snow reports from Glen Shee: Shona Ballantyne, Stuart Davidson and Kate Hunter

for help in the collection of materials to fill the snowballs: André and Linda Goulancourt and Andrew Morton (Highland cow hair); Leo Fenwick (horse chestnuts)

for vehicle maintenance: Robin Thomson of Keir Garage, Penpont

for help in the making of the snowballs at various times in Dumfriesshire and Perthshire: Julian Calder, Bob Clements, Wallace Gibson, Ellie Hall, Andrew McKinna, Simon Phillips, and Nick Spencer

for storage of some of the earlier snowballs after they had come off the Dumfriesshire hillsides and before their journey to Dundee: George Adamson and Keith Houliston of Galloway Frozen Foods, Dumfries

for storage of some of the Glen Shee snowballs until they could be transported to Dundee: Scottish Soft Fruit Growers Ltd of Blairgowrie, in particular, Flo Lynch.

for the transfer by low loader of the snowballs from the refrigerated transporters to their various locations in the City of London: Kevin Ball, Andrew Malcolm, Anthony Stone and Jack Turner of M Tec, Conrad Bodman, Carol Brown, Patrick Cameron, David Clark, Peter Greaves, Alison Green, John Hoole, Adrian Lockwood and Mike Marison from the Barbican, and my assistants Andrew McKinna and Simon Phillip.

Once the snowballs had been installed, students from the Faculty of Art & Design at the University of Hertfordshire, under the guidance of their Dean, Chris McIntyre, and Head of Department, Judy Glasman, worked in four teams to record the melt on video, which was then showed as a continuous loop as part of my exhibition, *Time*, from 30th August in the Curve gallery at the Barbican. Judy Glasman acted as video producer and provided project guidance; the four main camera operators, who undertook most of the video filming and editing, were Helen Halliday, Anne Noble Partridge, Samuel Smith and Dorothy Szulc. Other students, who spent long hours walking from site to site, recording the progress of the melting snowballs, and − in some cases − standing nearby to discourage damage, included: Angela Ball, Maggie Banks, Serena Bellamy, Henriette Busch, Gillian Cousins, Rita Dare, Sarah Dorans, Lucy Evans, John Fisher, Veronica Furner, Caren Georgy, Emma Gosling, Sam Harrison, Chris Jefferies, Irene Measures, Helen Rainsford, Susan Rooke, Sylvana Taijah, Lily Tsang, Wendy Tuxill, Joe Walker, Stuart Waller, Julie Walters-Hill, Marilyn Whittle and Ewa Warwrzyniak.

The photographs that appear in this book were taken by a number of people to whom I am grateful for their help in the huge task of charting what was happening in so many locations over a period of several days: Julian Calder − pp 4, 26, 38 (all), 43 (top and bottom), 52 (top right), 54 (top), 62 (top), 68 (bottom), 89 (top right), 90-91, 94-95, 103, 126-167; Cameron & Hollis − pp 48 (top left and top right, centre left and centre right), 54 (bottom), 57 (bottom right), 81, 82, 83, 89 (bottom), 114 (top), 120 (top and bottom), 121 (bottom), 128 (top), 134 (top); Sarah Castle − pp 56 (bottom), 59 (centre), 77, 78 (top left and top right); John Cole − pp 59 (top), 62 (centre), 65 (top and centre), 66 (top), 67 (centre right, bottom right), 68 (top right), 71 (top and centre), 72 (top, centre and bottom), 73 (bottom), 75 (top left and top right), 80 (top right), 88-89, 94 (top, centre above, centre below, bottom), 110 (top), 134 (centre and bottom); Louisa-Jane Dalkeith − pp 73 (top) 131 (bottom left and bottom right); Chris McIntyre − pp 48 (bottom), 49 (all), 107 (top); Simon Phillips − pp 55 (bottom), 62 (bottom); David Reed − pp 52 (left), 56 (top), 57 (top), 59 (bottom), 63, 66 (bottom left and bottom right), 67 (top left, top right, centre left), 68 (top left, centre left, centre right), 69 (top left), 76, 89 (top left), 90, 93 (bottom), 104 (top), 107 (bottom left and bottom right), 111 (top left and top right), 121 (top), 130, 132, 137 (top).

All other photographs were taken by Andy Goldsworthy.